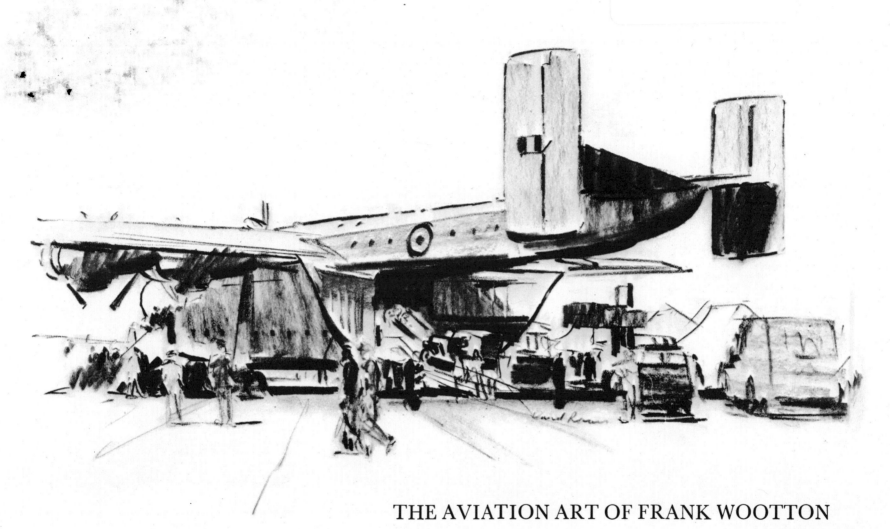

THE AVIATION ART OF FRANK WOOTTON

THE AVIATION ART OF FRANK
WOOTTON

Edited by David Larkin

Introduction by John Blake

A Peacock Press/Bantam Book
New York Toronto London

We are grateful to the Guild of Aviation Artists for their help in the preparation
of this book and also to the private owners, museums, the British Aircraft
Corporation and the serving members of the Royal Air Force.

An original PEACOCK PRESS/BANTAM BOOK

THE AVIATION ART OF FRANK WOOTTON

Library of Congress Catalog Card Number: 76-15475

PRINTING HISTORY:
First U.S. Edition: September, 1976

Bantam Books are published by Bantam Books, Inc. Its trademark,
consisting of the words "Bantam Books" and the portrayal of a bantam,
is registered in the United States Patent Office and in other countries. Marca Registrada.
Bantam Books, Inc. 666 Fifth Avenue, New York, New York 10019, U.S.A.

Published simultaneously in the United States and Canada

PRINTED IN THE UNITED STATES OF AMERICA
BY REGENSTEINER PRESS

Frank Wootton is a Sussex man, born and bred. It is the landscape and the
animals of Sussex that he paints, when he is not painting aircraft. He is a very
English painter, in the great tradition of Constable and Gainsborough, and has their
instinctive feeling for the land – and above all, in every sense – of the sky. In this
wide setting, his aircraft float, at home and natural. They *must* look as if they were
flying. He is, like Constable, much concerned with painting weather and after all,
weather is, as Frank says himself, one of the main considerations of the pilot
whenever he flies. His hangar and runway scenes are truly "landscapes with
figures" and he is unique in his ability to set this curious, ungainly, though often
beautiful, creation of metal and wood and fabric, the airplane, naturally among its
surroundings. He has a very close affinity with the aircraft that he paints, having
flown in most of them, but is emphatic that, in his own words,
"there are only certain types I would want to paint in a nostalgic way so that the
onlooker could share the interest one has in expressing the shape, texture, surface
characteristics of metal and canvas to the point where one instinctively wants to
touch it."

Frank Wootton was born in Eastbourne, and entered Eastbourne College of Art in 1928,

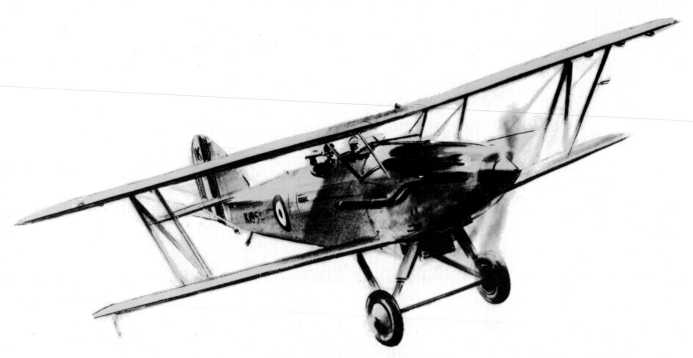

having abandoned early an academic career that promised him less reward than painting. He left the College in 1932 with a Gold Medal and a Traveling Scholarship, working subsequently in London as a free-lance artist until 1939 when, with the approach of war he volunteered for the Royal Air Force.

During the inevitable long wait until he was called up, he was occupied in illustrating various otherwise unrecorded aspects of the war for the Ministry of Information and various magazines. The drawings produced at this time, microfilmed and distributed for syndication to the United States and the Commonwealth, were extremely popular.

This was in 1940. During that year and 1941 he was occupied in a series of visits to RAF stations to record, at the invitation of the Director of Public Relations, Royal Air Force, Air Commodore Harold Peake, the activities of the Royal Air Force and Royal Canadian Air Force.

When he entered the Royal Air Force, he received an unexpected and unpleasant surprise. His technical drawings, dissected views of the compasses, bomb sights and other paraphernalia of the service, were found so useful by Training Command for instructing recruits, that every attempt to "get posted" was frustrated. It was, he confesses, the most dreary and unexciting part of his Service career. One thing, however, saved him from total boredom; a pre-war connection with the de Havilland Aircraft Company, for whom he had painted a number

of advertisements, enabled him to obtain a number of detachments to them early in the war. This resulted in the series of de Havilland Propellor Company advertisements, many of which formed the basis of three series of six prints issued by the Aeroplane magazine and were most people's introduction to his work. At the same time he was able to get in some flying, accompanying Geoffrey de Havilland on test flights of such aircraft as the Mosquito.

In 1944 he was summoned to Supreme Headquarters, Allied Expeditionary Force, at Bentley Priory, Stanmore, to meet the Commander-in-Chief, Sir Trafford Leigh-Mallory. There he was invited to accept a special commission to go to France to record the work of the RAF during the battle for Europe. This,

as his Training Command CO finally admitted, was one posting that could not be blocked. . . .

With three days to get his materials together, somehow obtain another uniform and catch an Anson at Northolt, he was driven down into Sussex to collect his gear. Squadron Leader Warner, of SHAEF's Air Reconnaissance Air Intelligence unit, providentially about the same size, provided the uniform and with a spare set of insignia belonging to the RAF Official Historian, Hilary St George Saunders, he was ready in time.

At the airstrip in Normandy where they landed, Frank was hospitably entertained by the Officer commanding 2819 Squadron, RAF Regiment, Colonel "Mossy" Preston of the Coldstream Guards, who now commands his

own art gallery in St James'. Here he began work, painting the first AA gun to bring down an enemy aircraft in the campaign, using an economic three rounds to do it.

Armed with a unique laissez-passer, signed by the C-in-C, that gave him unlimited freedom of movement and relying for transport on anything that offered, from communications aircraft to captured enemy vehicles – that sometimes had first to be disembarressed of their late occupants Frank Wootton set out to record the war.

Limited to the 56 lb baggage allowance of members of the RAF, there was no question of creature comforts, even the camp bed being discarded in favor of painting materials, which led to some remarkably hard lying. There was no question, either, of easels and camp stools and he was restricted to rolls of canvas and two frames, 30″ × 20″ and 24″ × 18″. As each painting was completed it was stripped off the stretcher and sent home. The ubiquitous jerrican provided a seat and Frank found it sensible to ensure that if one was sitting on a jerrican, it was an empty one. A non-smoker himself, he was nevertheless usually surrounded by interested onlookers who did.

Tremendous interest was always shown wherever he worked, and indeed still is. This has become apparent on one or two occasions where the usual inter-squadron rivalry exists between units sharing a base. More than once, having broken off work to accept a lift back to the Mess for lunch, he would find on his return that the aircraft he had been painting had been removed and replaced by a similar one from

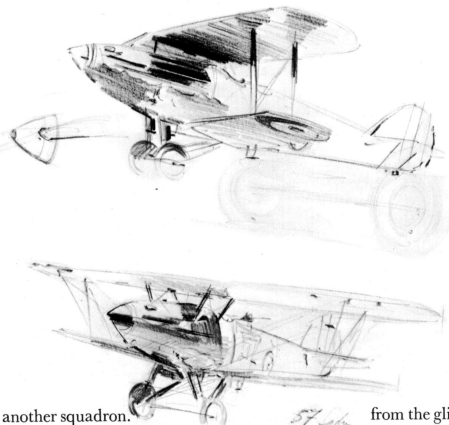

another squadron.

On one memorable occasion, painting under difficult conditions in Normandy, when things were not going very well with the job in hand, an aircraftman who had been watching with great interest remarked on departing, " 'Ere, 'ave you read that book on 'ow to Draw 'Planes, by Frank Wootton?"

As a medium, he used petrol culled from the bottom of the convenient jerrican. Satisfactory in that it dried quickly, it eventually left the painting looking rather muddy and sad. Whenever he managed to catch up with his works afterwards, which did not happen very often, Frank would revive this lifeless surface with judicious varnishing.

He painted a wide variety of subjects, ranging from the glider sites and dropping zones of 6th Airborne round Pegasus Bridge on the Orne River, to the scene on the 35 Wing airfield at Ghent after the Arnhem operation, where, although the PRU Spitfires were not actively engaged in "Market Garden", many battle-damaged aircraft came to rest and Frank painted the repair crews dismantling them.

He spent some time with the 35 Wing reconnaissance unit, painting the Spitfires and Mustangs of Nos. 2, 4 and 268 Squadrons, whose daily photographic cover kept him up to date with events and indicated likely salient points of interest to record. Here he met Squadron Leader Laurence Irving, the Wing Intelligence Officer, and a painter himself, who always knew precisely what Frank wanted to do and is now a

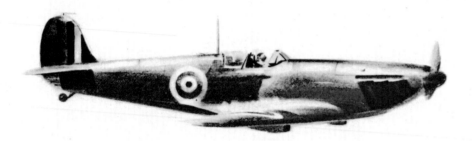

Sussex neighbour.

His most famous work in this period was undoubtedly done with 121 Wing of 83 Group, whose rocket-firing Typhoons of 174, 175 and 245 Squadrons provided some of his most dramatic paintings. It had been a very dry, hot summer, and northern France was covered in the undisturbed dust of four years. Like the roads, the airstrips lay under a perpetual cloud of this dust and in it the Typhoons landed, rearmed and refuelled and took off.

The painting of Typhoons attacking German armour in the battle of the Falaise pocket is probably the most famous of all that Frank produced at this time. In this battle, when the German 7th Army was virtually annihilated by attacks from the air, long columns of armor and

soft-skinned vehicles were destroyed. Using techniques developed in the Middle East in the first World War, the Typhoons smashed the head and tail of each column, immobolizing it and returning to destroy the rest at leisure. Some of the detail was, he found, unpaintable; anyone who was there will recall the ditches filled with dead and smashed horses, many of them stolen from the French, that made up much German transport strength.

Towards the end of 1944, Frank Wootton was summoned back to England, to another interview with Leigh-Mallory. The war in Europe was nearly finished, Leigh-Mallory told him. He had been appointed C-in-C in the Far East; would Wootton like to accompany him and record the jungle war? A place was

available on the C-in-C's private aircraft. He had also arranged, at his farewell party, an exhibition of the work Frank had done in Europe. (It was, Frank relates, the last time he saw any of these until 1976, when sixteen were put on exhibition, from various stations in the Command, by Strike's C-in-C, Sir Denis Smallwood.)

Conscious of the fact that all his kit and materials had been left in Belgium, and had to be collected, the offer of a lift in the C-in-C's aircraft had to be declined and Frank left later. The York containing Sir Trafford and Lady Leigh-Mallory and their staff came down in the Appenines in November. It was not found until the following spring.

Sir Keith Park, who had been A.O.C. 11 Group in the Battle of Britain and commanded the RAF in Malta during its seige, was C-in-C when Frank Wootton arrived in India. The nearest action was at Salbani, where the Liberators of 356 Squadron were bombing Rangoon, and there Frank went, painting the squadron and getting acclimatized.

From Salbani he flew down to Mingaladon, Rangoon, to record the Spitfires and Mosquitos attacking the Japanese from monsoon-flooded strips. It was not uncommon to find the mud and water so deep as to tip a landing Spitfire onto its nose. It was during this period that he constructed for himself (having, as usual, no camp bed) a stretcher of bamboo supported on two ammunition boxes, much to the amusement of the officers who shared his

tent, veterans who viewed this newcomer's antics with delight. That night the monsoon burst and in the morning the newcomer, although only inches above the flood, could regard with complacency the other occupants, searching in the flood for lost kit.

Also in Rangoon, he met another RAF war artist, Thomas Hennell, later unfortunately killed. Hennell was obviously much more interested in painting the landscape and figures and portrayed aircraft with an indifference that infuriated the crews and pilots. On one occasion, asked what he was painting, Frank described the exciting subject made by the supply dropping Lysander, painted black all over for night operation and hung about in unlikely places with strange bundles. Hennell accompanied

him to see this for himself, gazed at it in amazement for some time and then left, remarking "It looks just like any other aircraft to me."

From Mingaladon to Meiktila and again Frank's luck held good. The Dakota in which he was traveling was stopped at the end of the runway and he was bundled out to make room for a senior officer. Frank departed later on the little aircraft that delivered mail along the route and on arrival at Meiktila learned that the Dakota was missing.

Meiktila, showing the scars of the many battles for its possession, housed Hurricanes and Thunderbolt fighter bombers. On one occasion, while painting a pair of Thunderbolts taking off, Frank saw a 500 lb bomb detach itself from

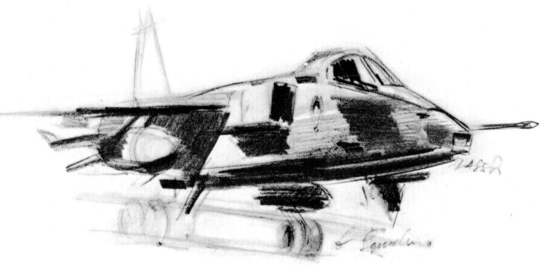

its rack, skip neatly over his head and land a few yards away fortunately without going off.

From this period dates one of his favorite souvenirs, a Daily Routine Order, not long after VJ-Day, announcing a competition for a Victory poster, to encourage morale: "Open to all ranks currently serving in the Command (Wootton barred)."

Since the war, despite a growing concentration on landscape and animal painting, Frank Wootton has continued to paint aircraft. In the words of Laurence Irving, "By established himself as pre-eminent in an entirely new element, depicting the endeavour of the Royal Air Force and all its aircraft in the limitless perspective of its element."

He has been for many years an active and constructive President of the Guild of Aviation Artists, whose annual reports as chief judge of the major competition and exhibition are valued documents. It is in this particular sphere of activity, perhaps, that one of his most outstanding characteristics is revealed, for no artist can have been so generous of his time and talent in advising the many Guild members, professional as well as amateur, who come to him for aid.

John Blake

High Flight

Oh! I have slipped the surly bonds of earth,
And danced the skies on laughter silvered wings:
Sunward I've climbed, and joined the tumbling mirth
Of sun-lit clouds – and done a hundred things
You have not dreamed of – wheeled and soared and swung
High in the sunlit silence. Hov'ring there
I've chased the shouting wind along, and flung
My eager craft through footless halls of air.

Up, up, the long delirious, burning blue!
I've topped the wind-swept heights with easy grace
Where never lark, or even eagle flew:
And, while with silent, lifting mind I've trod
The high untresspassed sanctity of space,
Put out my hand – and touched the face of God

<div align="center">

JOHN GILLESPIE MAGEE

</div>

*John Gillespie, 19, was killed in action in the skies
of England during December 1941. Though brief his
life was rich in experience and emotion and he has
been given recognition as a poet of rare and moving
talent. Son of an American missionary and of an
English mother. He was born in Shanghai, and at the
age of nine, came to England where he was educated
at Rugby.*

Any artist who has pursued his subject for forty years
through war and more peaceful times must be indebted to
numerous kind people who have assisted in many ways.

I am greatly indebted to Air Commodore Harald Peake
who gave me my first insight to the RAF at war, and
to C. Martin Sharp and John E. Scott of the de Havilland
Aircraft Company with whom I enjoyed a long standing
patronage.

Two friends must be named here, Squadron Leader
W. Warner and Group Captain C. W. B. Urmston who,
in a matter of days, arranged my transfer from
RAF Training Command to a Special Duty Commission
in Normandy with the 2nd TAF, with the blessing of
the C-in-C SHAEF Sir Trafford Leigh-Mallory.

While in Normandy I received great encouragement
and assistance from that most perceptive Intelligence
Officer of 35 Wing, Squadron Leader Laurence Irving, OBE.
He supported my enthusiasm with a complete understanding
and helpfully gave me facilities to visit the battle
areas I wished to record.

I would also like to express my appreciation of the
interest and assistance I have received from:
Air Chief Marshal Sir Andrew Humphrey, GCB, OBE, DFC, AFC, ADC,
Air Chief Marshal Sir Denis Smallwood, GCB, KCB, DSO, DFC, RAF,
Air Chief Marshal Sir Neil Wheeler, GCB, CBE, DSO, DFC, AFC,
Marshal of the RAF Sir Dermot Boyle, GCB, KCVO, KBE, AFC, RAF,
Director of the RAF Museum, John Tanner, MA, PhD, FRHistS
and finally Air Vice Marshal C. M. Gibbs, CBE, DFC, RAF, who
kindly supervised the location and collection of the
paintings owned by the various units of the Royal Air Force.

 FRANK WOOTTON

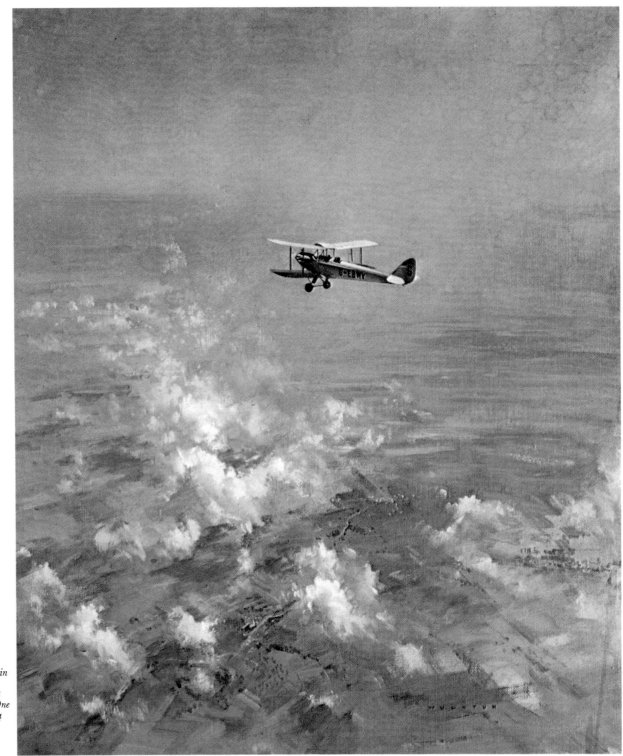

1) Altitude Record

"Flying from Stag Lane Aerodrome on July 27, 1928, Captain Geoffrey deHavilland, with Mrs. deHavilland as passenger, established a new world's altitude record for two-seater light aircraft. His standard Gipsy Moth with 85-100 h.p. Gipsy One engine (D.H.60G-G-EBWV), climbed to 19,960 ft. (6054 metres) in one hour ten minutes."

By kind permission of Hawker Siddeley Aviation Ltd.

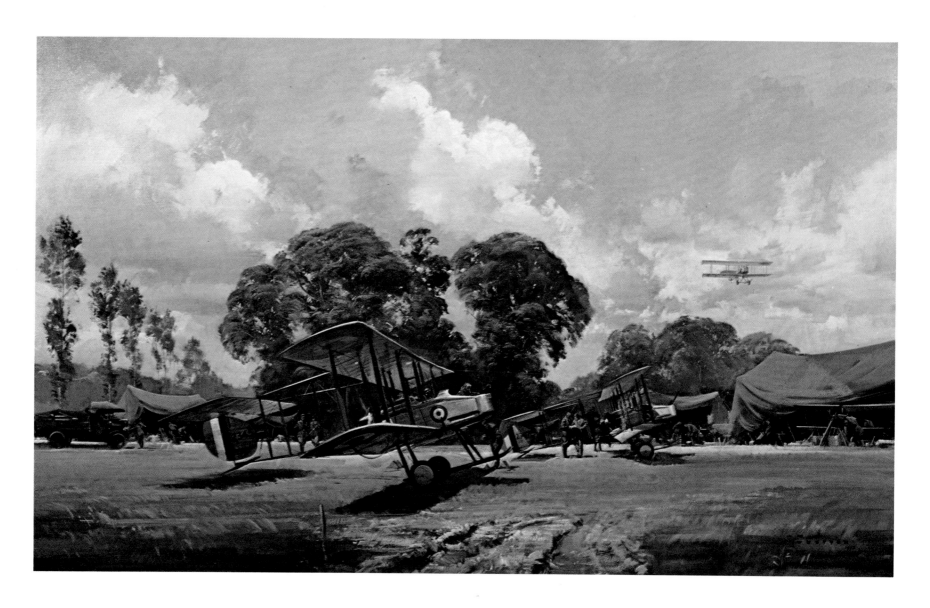

2) Vickers FB5 Gunbus

*"Commissioned by the RAF Museum and painted from the
replica owned by the Museum. The Gunbus as it became known,
equipped the first RFC Fighter Squadron 11 in France, July 1915."*

By kind permission of the Royal Air Force Museum

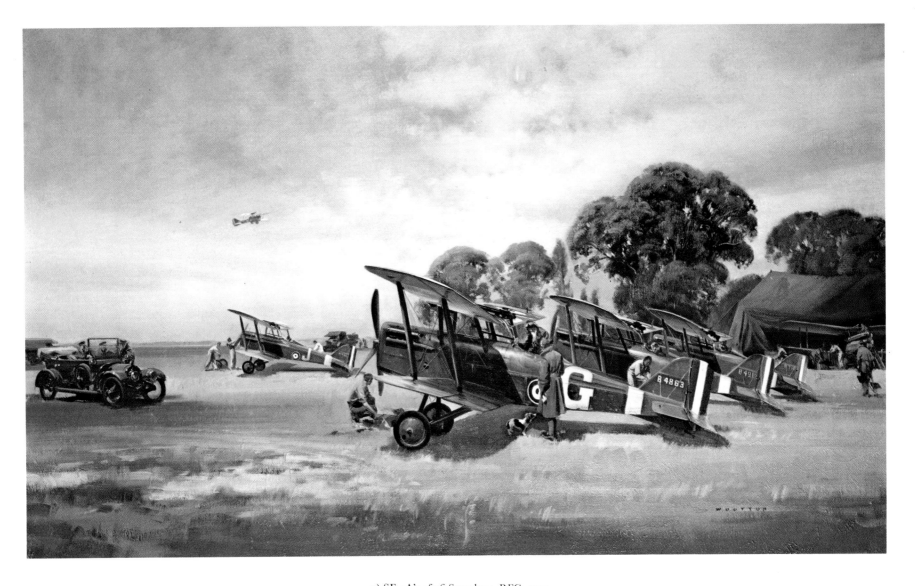

3) SE 5A's of 56 Squadron, RFC, 1917.

"One of the elite squadrons of the RFC. 'B' Flight Squadron was commanded by James McCudden, later to become Captain James McCudden, VC, DSO, MC, MM. The Squadron aircraft were distinguished by a broad white band painted on the rear of the fuselage. McCudden's machine had the letter 'G' painted on the fuselage and the wings."

By kind permission of James B. Fleming, Alamo, California

4) Hawker Harts, 57 Squadron, RAF.

*"This was Sidney Camm's favorite aircraft, it is also one of mine.
The first airplane I ever painted was a Hawker Hart of 25
Squadron in 1935. The Squadron was based at Hawkinge,
60 miles away, I cycled there on an open day when the RAF were
giving a flying display.*

*"In 1957 I was a guest at a special occasion at Headquarters
Bomber Command. It was here I met Air Vice-Marshal K.B.B.
Cross. In the course of conversation I discovered that he was a
Flying Officer in 1935 attached to 'A' Flight based at Hawkinge.
I later sent him my first painting, by some extraordinary coincidence
the serial number of the Hart I painted was K2052 which the
AVM confirmed from his Log Book was his aircraft."*

Owned by the Artist

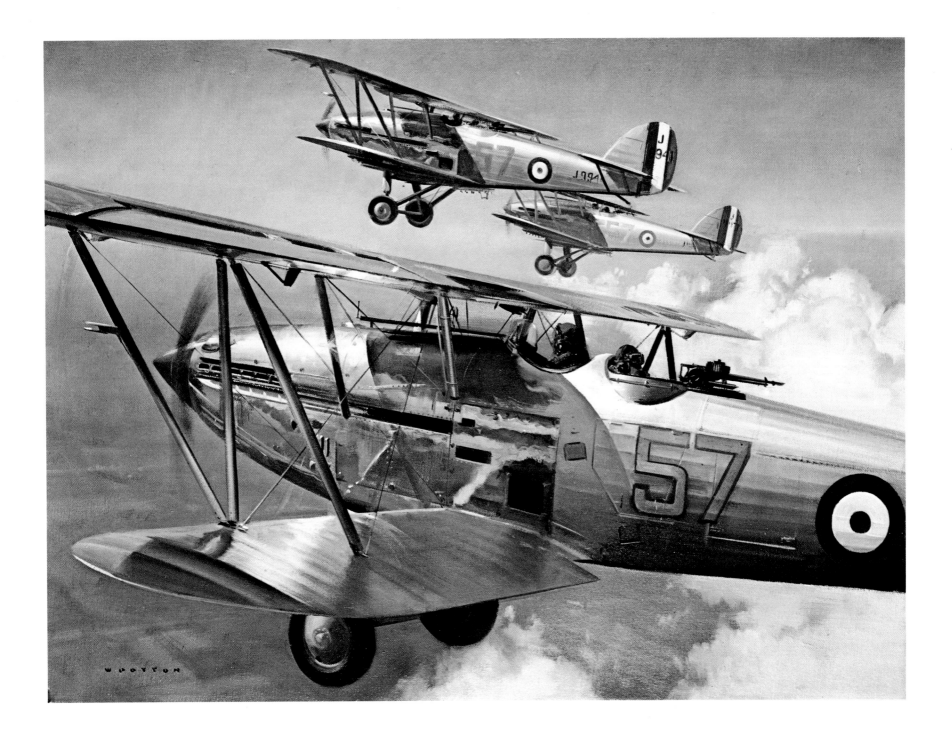

5) Handley Page Hannibal of Imperial Airways, Croydon Airport.

"The H.P. 42 Biplane was designed to operate on the Middle East and Egyptian sections of the Imperial Airways system. During this period, 1934-35, these aircraft contributed to a wonderful record of realibility and safety enjoyed by Imperial Airways."

By kind permission of Royle Publications Ltd., London

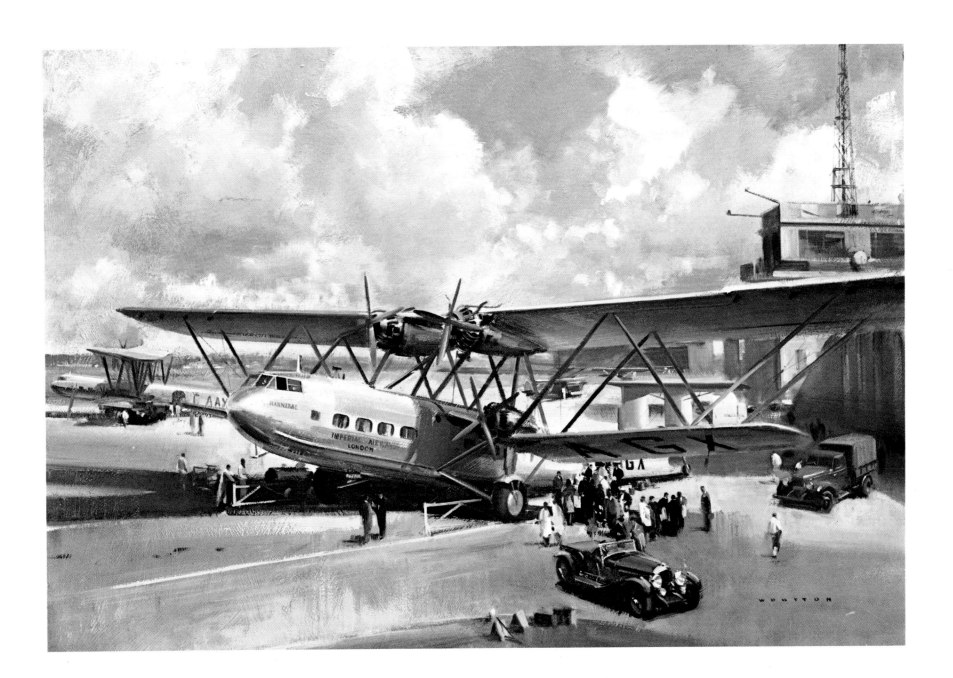

6) Tiger Moth, Trainer of the Empire

"Painted for the de Havilland Aircraft Company in 1940. Thirty-five years later this painting was found in a shed on a disused airfield. It had been taken off its stretchers and folded many times, like a map. I wonder what happened to the owner? However, the painting was brought to me and I restored it."

By kind permission of Mr. M. Mandall.

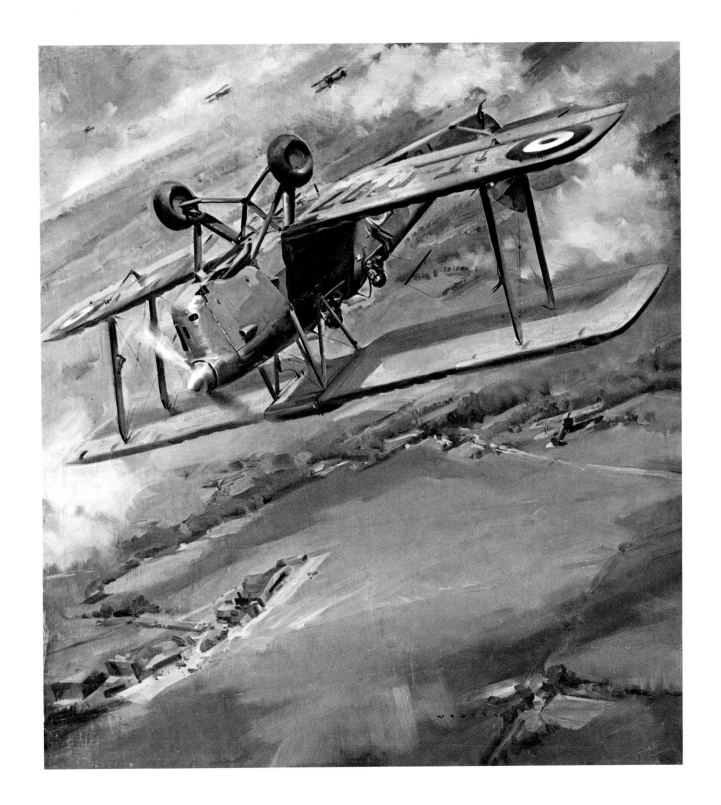

7) deHavilland Rapide of Scottish Airways.

"Painted during the war. Captain Fresson operated this airline linking the Shetland Isles with the mainland."

By kind permission of Hawker Siddeley Aviation Ltd.

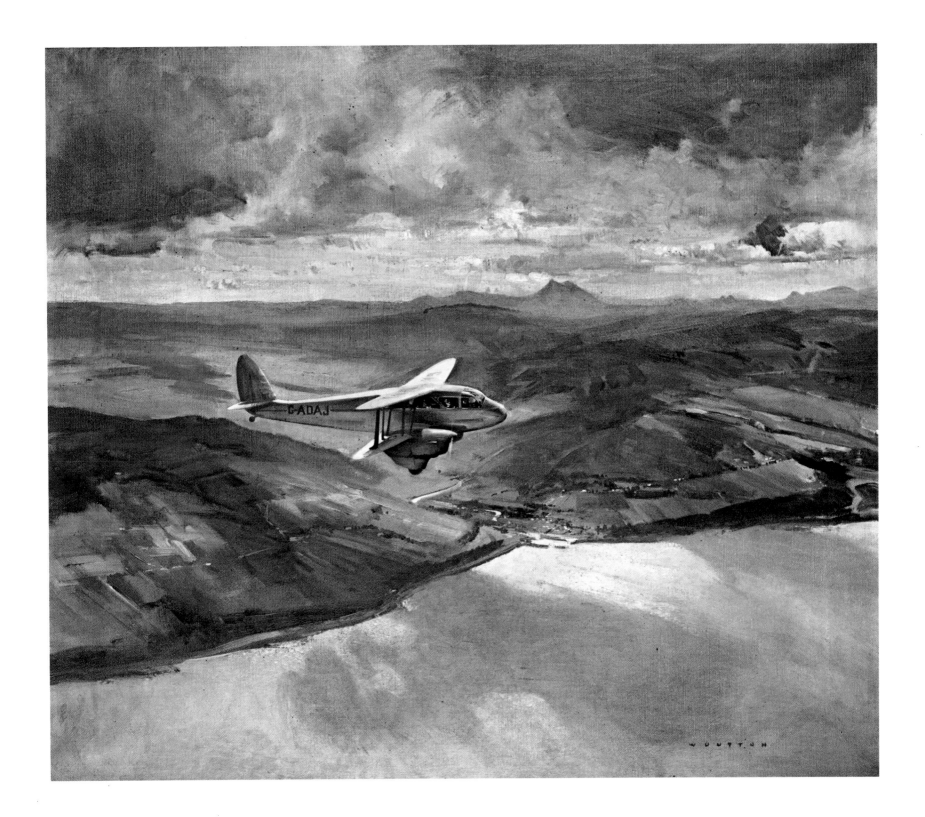

8) Hawker Harts of 11 Squadron RAF Over the Himalayas

"This is the North West Frontier Province. A typical routine flight undertaken by 11 Squadron was to fly up to Gilgit, (the birthplace of polo, I believe) the object being to give support to the Political Agent stationed there, also to deliver and collect important mail. Based at Risalpur, India, these aircraft were constantly in action against marauding tribesmen. The crews did not wear leather flying helmets, but khaki polo topees with the front peaks cut off so as not to interfere with their goggles.
I flew to Gilgit in 1968 and painted the background. Nanga Parbat can be seen in the distance. The Hawker Hart was much nearer home, kept in flying condition at Dunsfold, Surrey."

Presented to the RAF Museum, Hendon by the Artist.

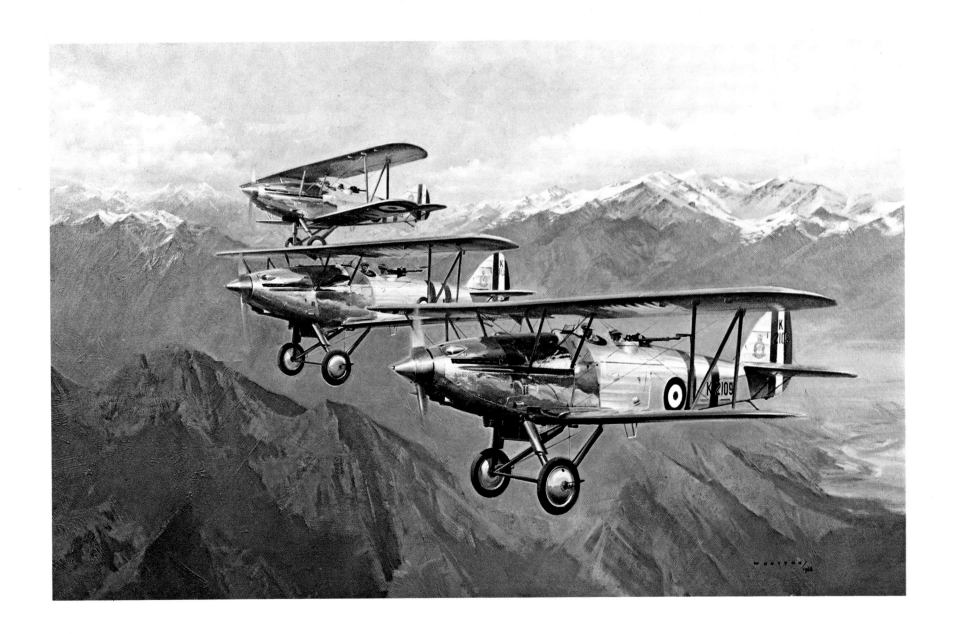

9) Defiants Enroute to Dunkirk

"A symbolic picture of the period when we had our backs to the wall."

By kind permission of Strike Command, RAF

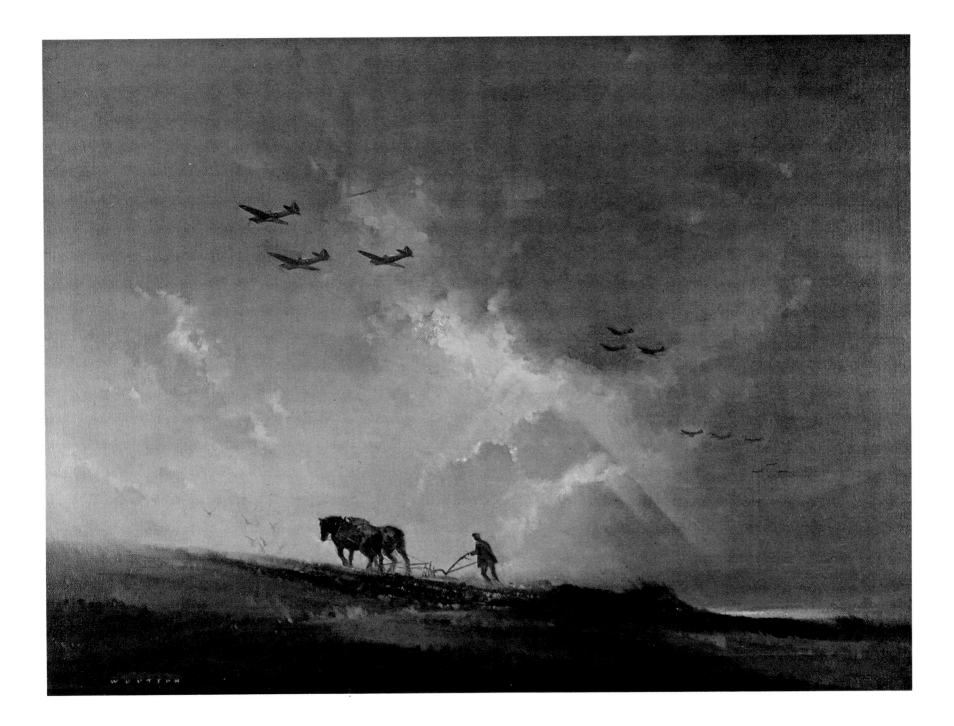

10) Looking for Trouble

*Spitfires of No. 11 Group searching for enemy aircraft during
the Battle of Britain, September 1940.*

By kind permission of H.Q. 11 Group Strike Command, RAF.

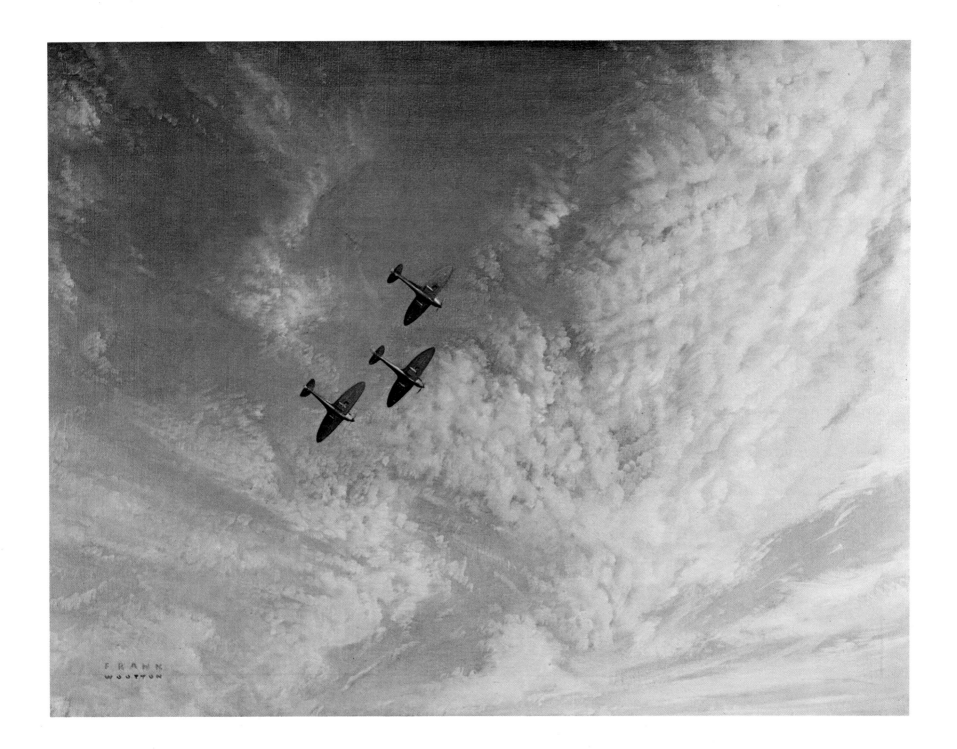

11) Battle of the Dinghy

*"Squadron Leader Michael Robinson DSO, DFC, leading
609 Squadron on May 8, 1941 (his birthday). Two British
air-sea rescue launches were attempting to rescue an important
German aviator who had been shot down in the Channel and had
taken to his dinghy. The rescue launches were attacked by
Messerschmitt 109's, one launch was set on fire. Four
Messerschmitt's were destroyed, plus two probables, for two
Spitfires damaged. The action was described to me by Squadron
Leader Robinson when I visited Biggin Hill."*

By kind permission of 609 Squadron, RAF

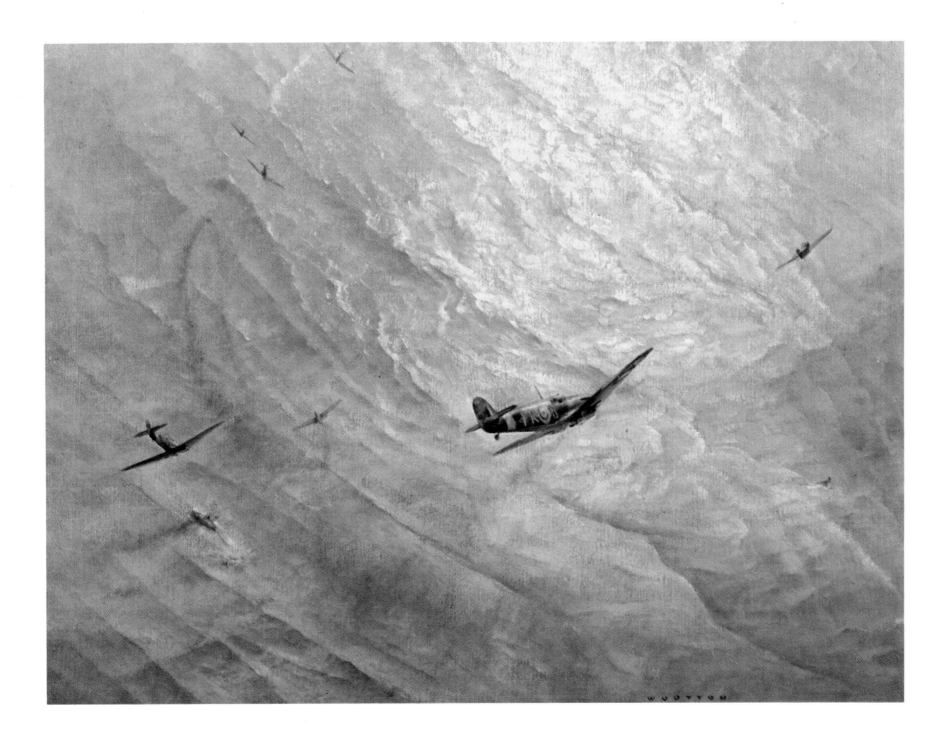

12) Flight Lieutenant John Dundas, DFC and Bar shooting down Helmut Wiek, Kommodore of JG2 (Richthofen) Geschwader, November 29, 1940.

"*Wiek was credited with 56 victories, Dundas 13 and this his last, for he was shot down himself by the German leader's No.2.*"

By kind permission of 609 Squadron, RAF

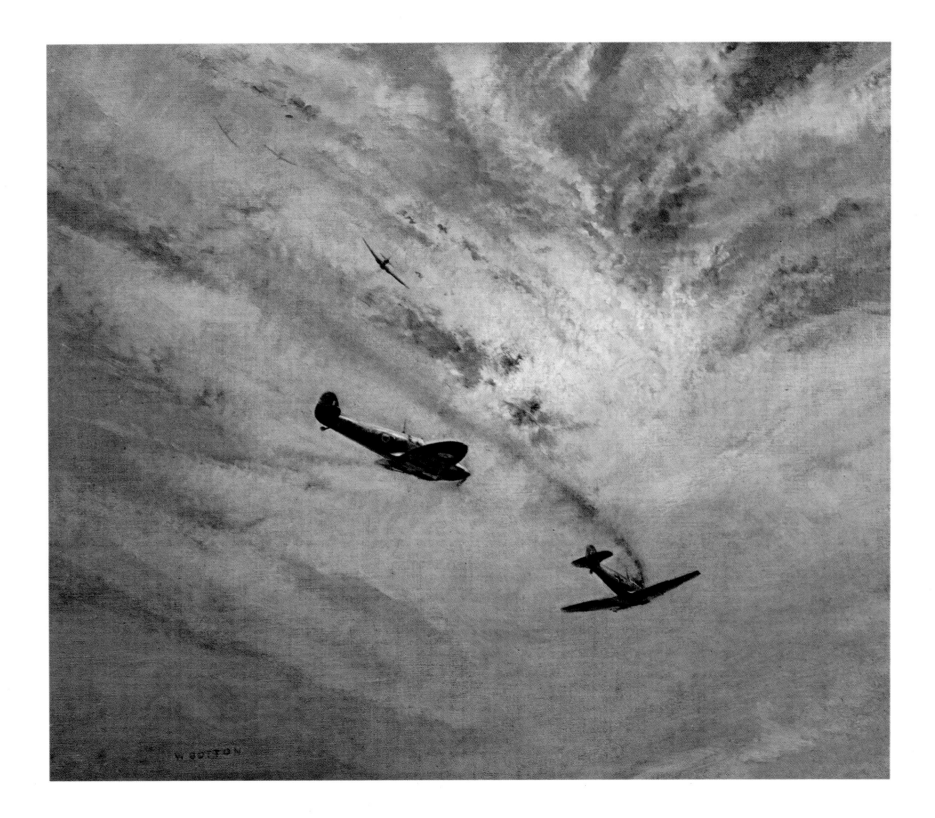

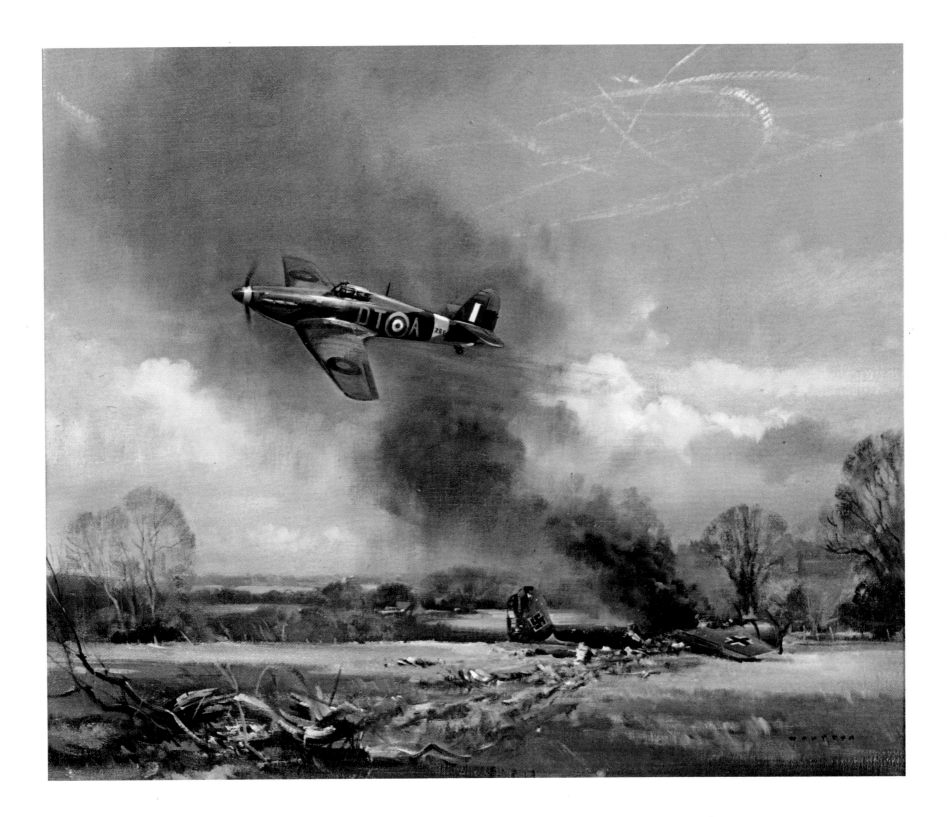

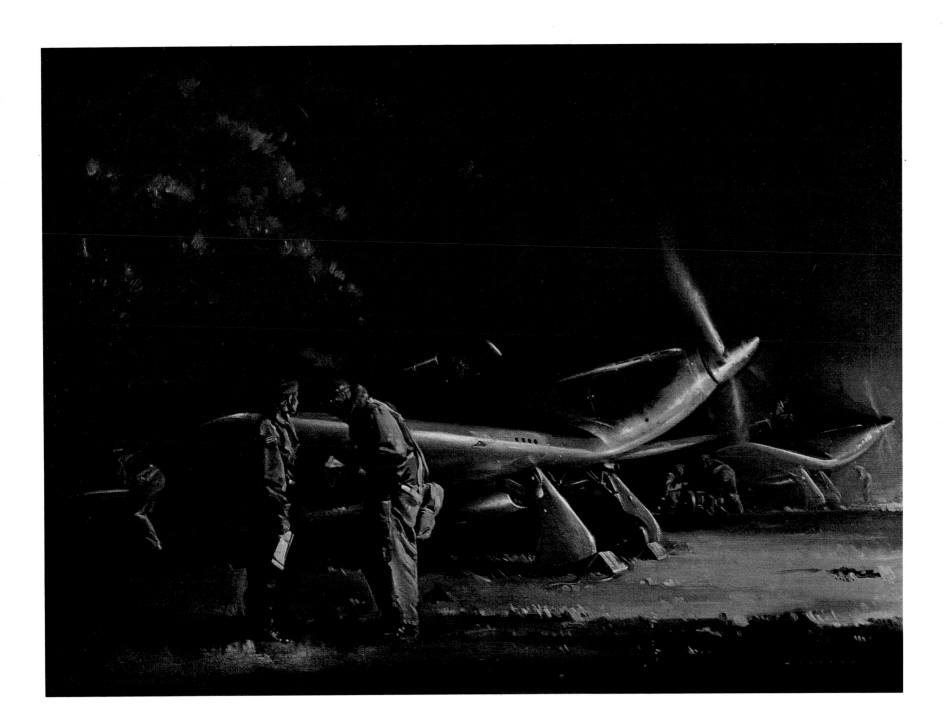

15) Wellingtons taking off at dusk.

"One of a series of six commissioned by the Airscrew Division of the deHavilland Aircraft Company in 1940 and published as fine art prints for the sole benefit of the Royal Air Force Benevolent Fund."

By kind permission of Strike Command, 1944

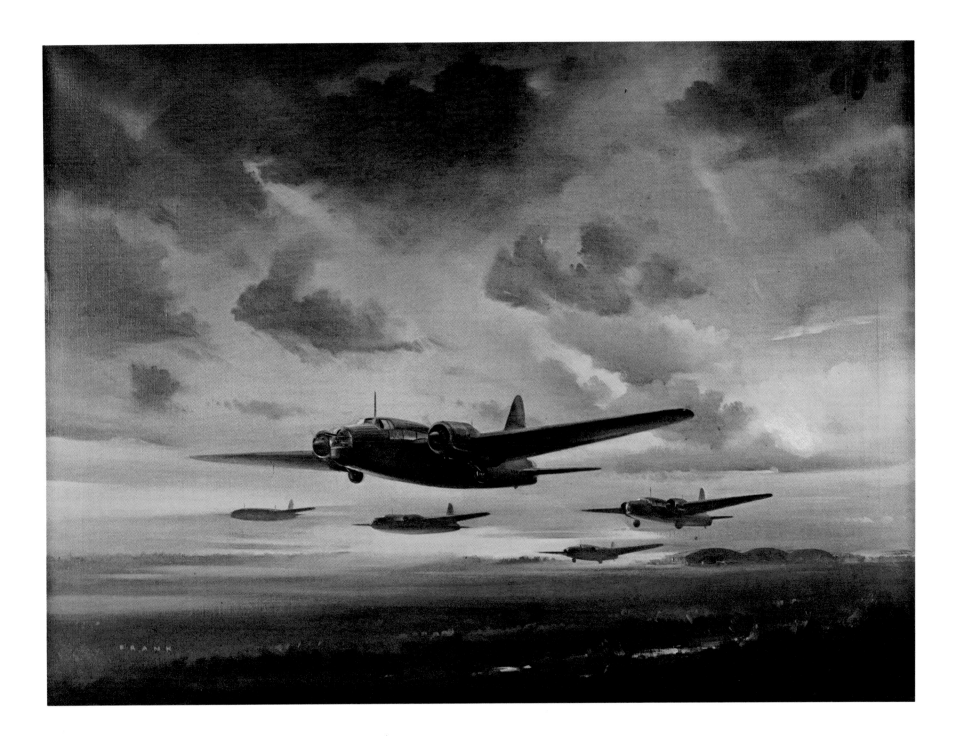

16) P.R.U. Spitfire

"The use of high altitude Spitfires for photographic reconnaissance was developed by F. S. Cotton, OBE in the early stages of the war and led to the formation of the Photographic Development Unit at Heston on 17th January 1940. This unit which expanded quickly, was renamed Photographic Reconnaissance Unit and placed under the command of Wing Commander G. W. Tuttle, OBE, DFC on the 8th July 1940.
The painting shows Flight Lieutenant Neil Wheeler returning from a reconnaissance flight over Germany in early summer 1941. In order to carry extra fuel, cameras and additional oxygen bottles, all armament and radio equipment was removed from the aircraft, and it was not until 1942 that any heating was provided in the cockpit."

By kind permission of Air Chief Marshal Sir Neil Wheeler, GCB, CBE, DSO, DFC, AFC.

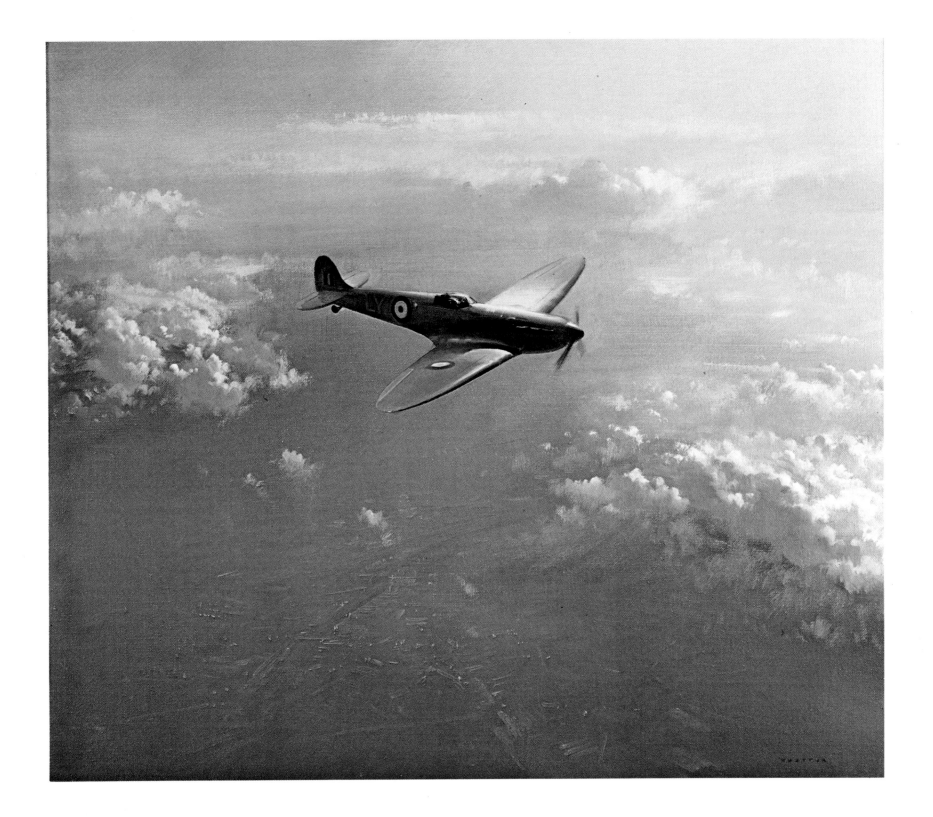

17) Lancasters crossing the Alps.

"The night of 22/23rd October 1942 a hundred Lancasters rained their bombs on Genoa. The moon was almost full. The Pathfinders found their objective without difficulty. Many acres of the town were devastated, the docks, shipping and the Ansaldo fitting yards were all heavily damaged. Not a single bomber fell to the defences."

By kind permission of the Royal Air Force Staff College

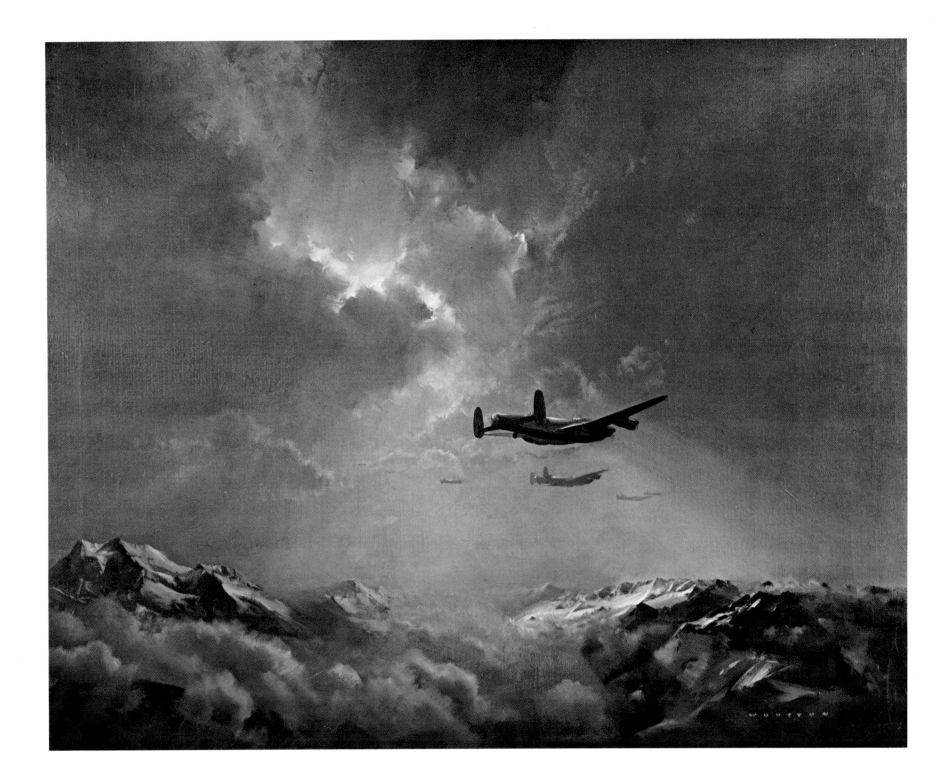

18) Beaufighter Strike

*"Led by Wing Commander Neil Wheeler, 27 Beaufighters of the
North Coates Wing attacked a heavily escorted convoy off the Dutch
coast on June 22, 1943. High level protection for the Beaufighters
was provided by Spitfires and Typhoons of Fighter Command.
The role of 143 and 236 Beaufighter Squadrons was to attack the
escort vessels of the convoy with rockets, cannon and machine gun fire
in order to enable 254 Squadron, which carried torpedoes, to attack
the larger merchant vessels."*

Owned by the Artist

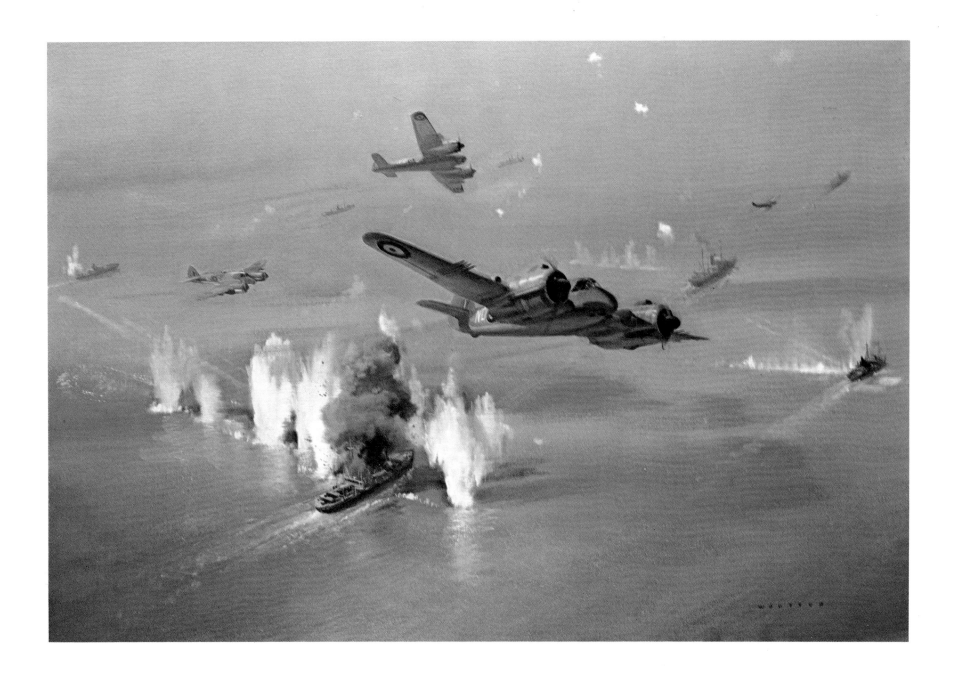

19) Hampdens 'bombing up', RAF, Waddington.

"Painted at Waddington during the war. It was a large canvas for working on outside. I had prepared a simple wooden support expecting a grass field. This had worked well on previous occasions, however, it was useless on the tarmac. I lashed the canvas to a spare aircraft jack, it made a good easel."

Commissioned by Sir Frederick Handley Page and presented to RAF, Waddington.

By kind permission of Strike Command, RAF

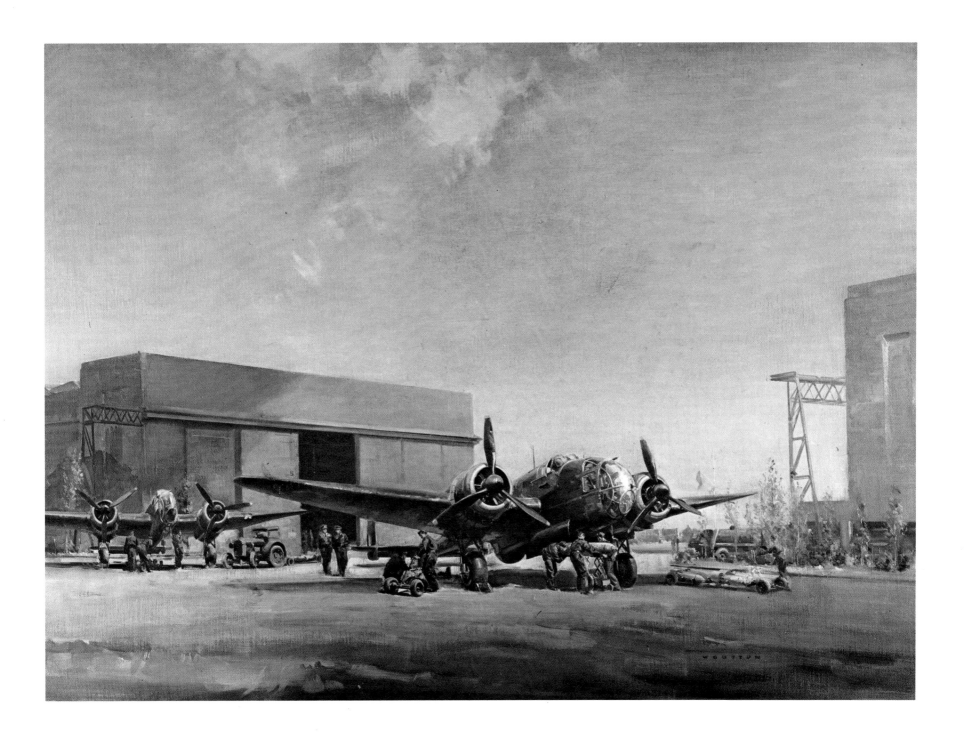

20) Blenheims Over the Target

"Commissioned by the Airscrew Division of the de Havilland Aircraft Company in 1940. Painted largely from imagination and with the aid of a wooden model I made for the purpose of obtaining a true impression of the aircraft by moonlight."

By kind persmission of Strike Command RAF.

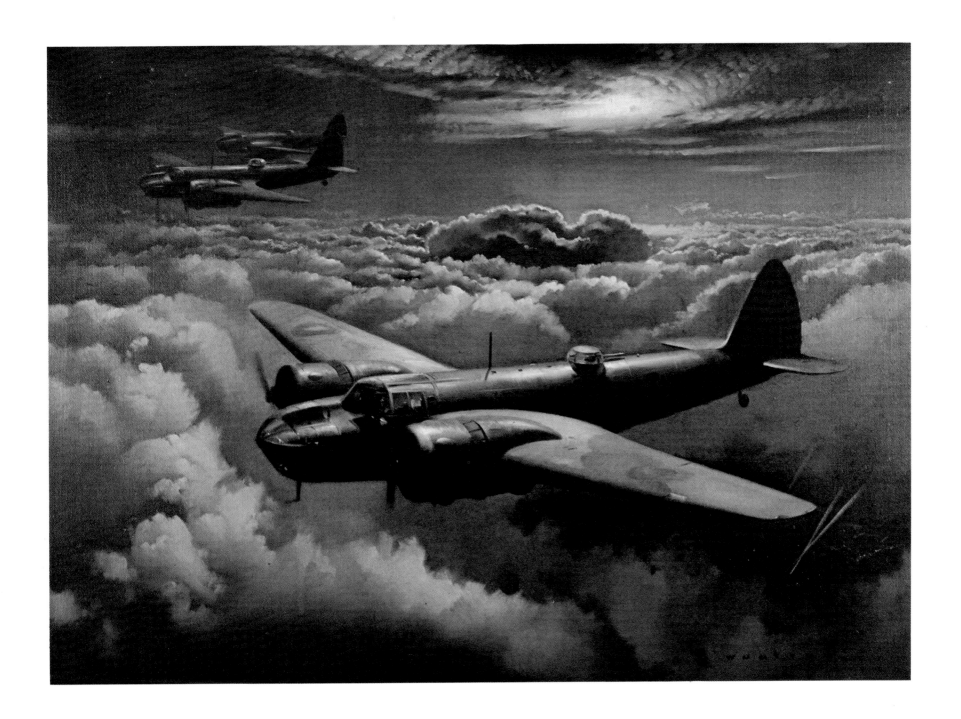

21) Low Attack — The Mosquito Technique

"This took place on April 1, 1943, the 25th Anniversary of the formation of the RAF. Six aircraft of 105 Squadron led by Squadron Leader Ralston were accompanied by six aircraft of 139 Squadron. Rain and low cloud prevailed for most of the way, the target was the railway sheds at Trier. The bombing was precision itself, a perfect concentration of bursts fell on the sheds and transport. One aircraft was damaged by the bursts of the leaders bombs, but returned safely on one engine."

By kind permission of Strike Command, RAF

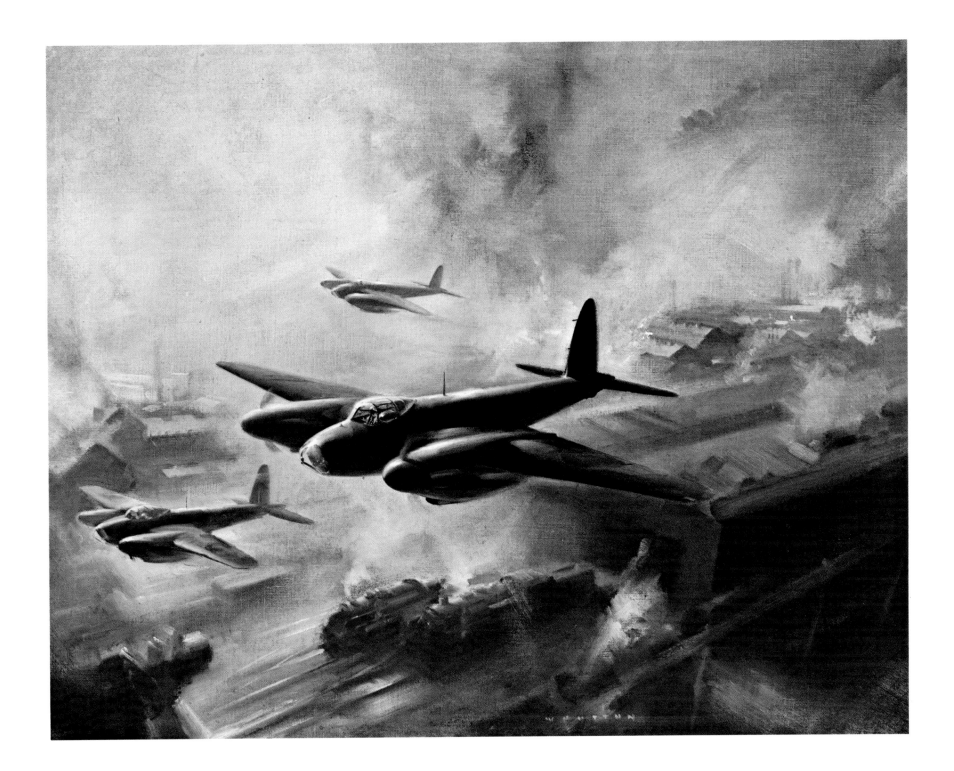

22) Hornet in a near vertical climb over Hatfield.

"Commissioned by the deHavilland Aircraft Company shortly after my return from Burma. I flew with Geoffrey deHavilland who was testing the aircraft. The performance of the Hornet was exceptional, on leveling out at the top of a climb I had to retrieve my sketch book in mid-air as it climbed vertically off my knee."

By kind permission of Hawker Siddeley Aviation Ltd.

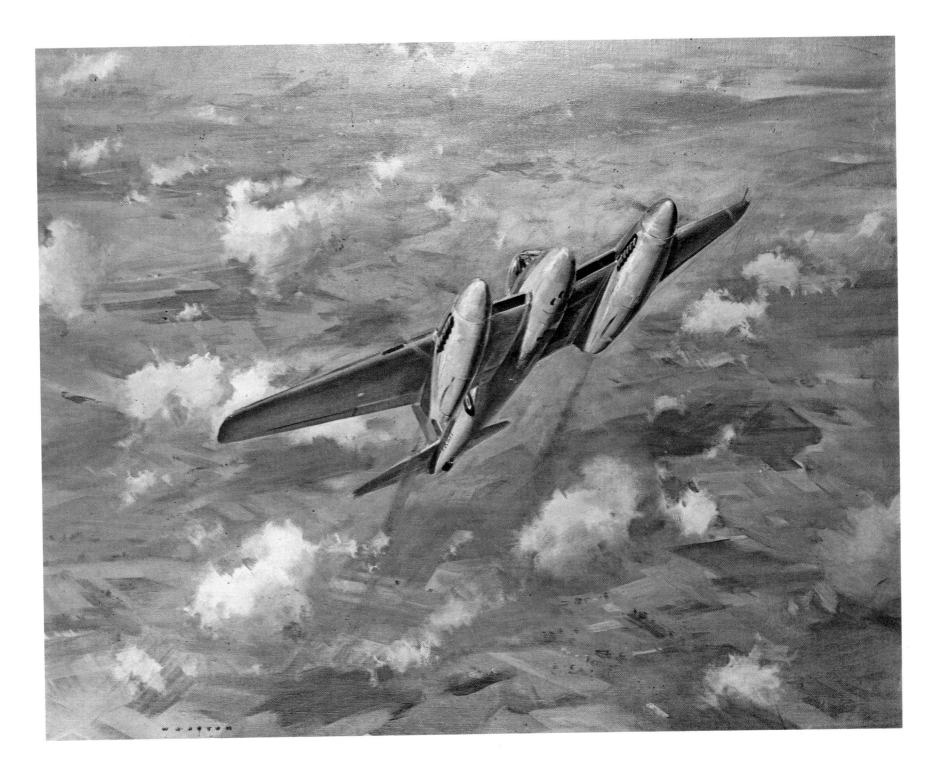

23) Boeing B-17 Flying Fortress

The 8th United States Air Force returning from a daylight bombing raid on Germany 1943.

"This aircraft completed twenty-five operational missions from England and although badly damaged on numerous occasions by flak and fighter cannon fire, returned to the U.S.A."

Owned by the Artist.

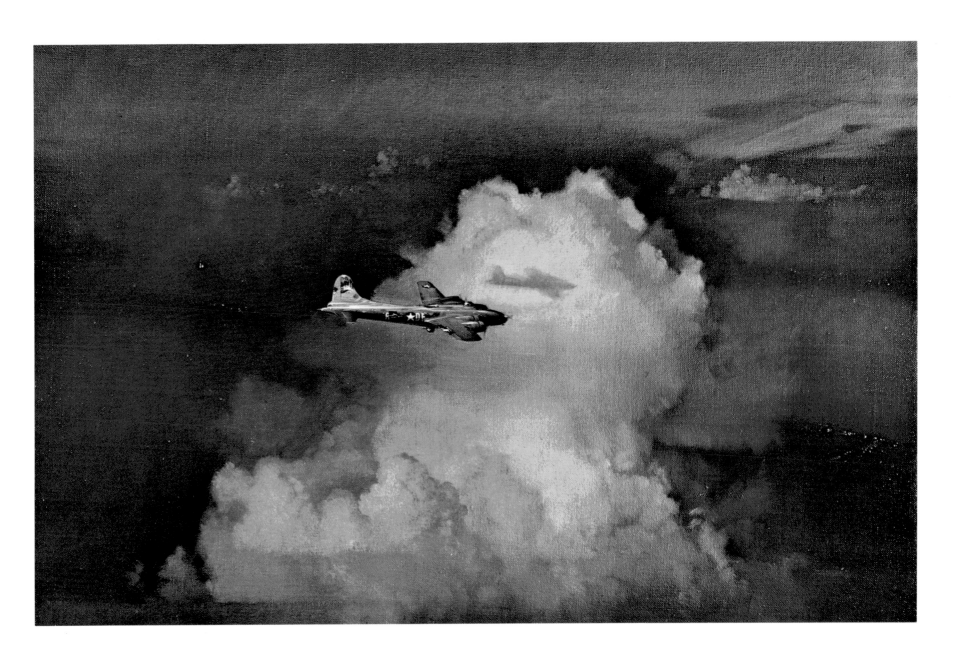

24) Mustang photographing a German V1 site, Pas de Calais.

"A MK11 Mustang of 170 Squadron, 35 Wing, PRU making a low level reconnaissance flight on November 9, 1943 photographed a German V1 site under construction. The Flying Bombs known as the V1 (Vergeltungswaffe), meaning retaliation weapon, were launched from 'sky sites'. Several hundred of these sites were constructed. All were between 130 and 140 miles from London. The Flying Bomb has a warhead containing 1,870 pounds of high explosive, was jet propelled and directional control was secured by gyroscopes with speed from about 500 kilometres an hour. Most of these sites were hidden as far as possible in woods to escape detection from the air. By the end of May 1944 103 sites out of 140 had been destroyed by Bomber Command."

Owned by the Artist

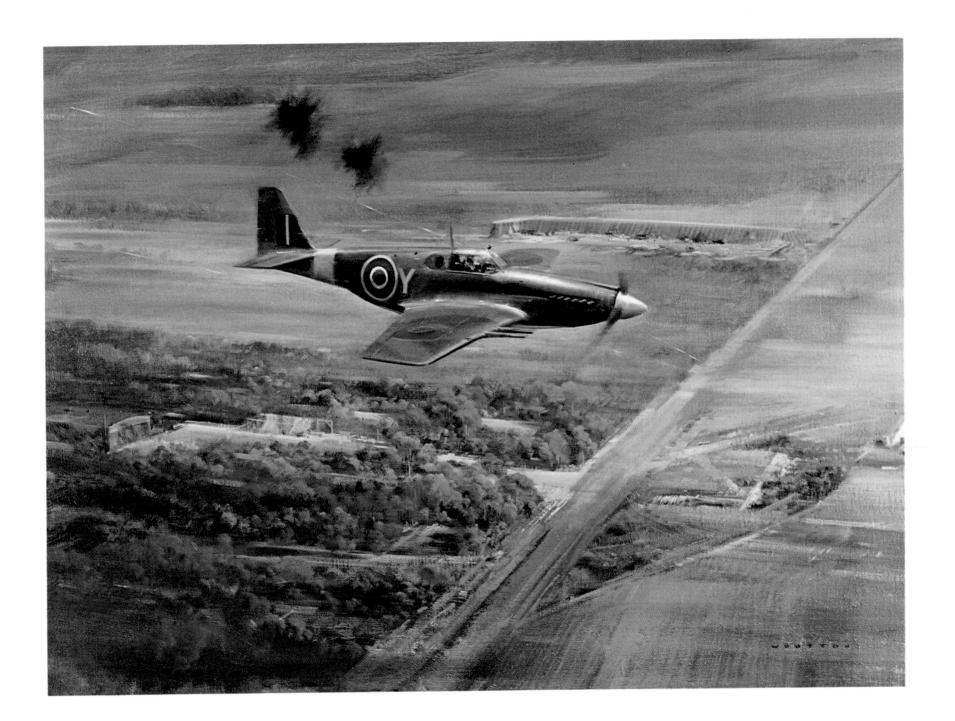

25) Major Inspection, Lysander, 400 Squadron, RCAF.

"Painted at Odiham in 1940. While painting this I received two visits from the Engineering Officer. After looking at my painting he instructed one of the men to clean up an oil slick on the hangar floor. When this had been done to his satisfaction he came to me and asked me to remove it from my painting."

Presented to the Royal Air Force Museum by the Artist

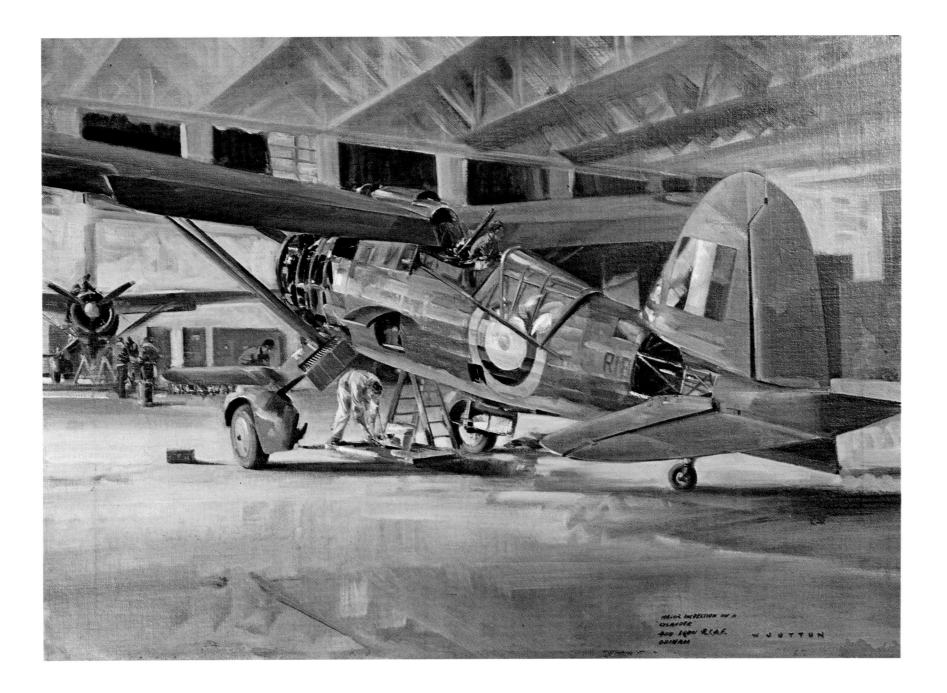

MAJOR INSPECTION ON A
LYSANDER
400 SQN R.C.A.F.
ODIHAM

W J OTTON

26) Auster landing at headquarters site, Normandy.

"Used for liaison and observation the Taylorcraft Auster III was a popular aircraft that could be used on unprepared fields and stretches of roadway. It is seen here slipping into one of the more comfortable battlefront headquarters of the RAF."

By kind permission of SBAC

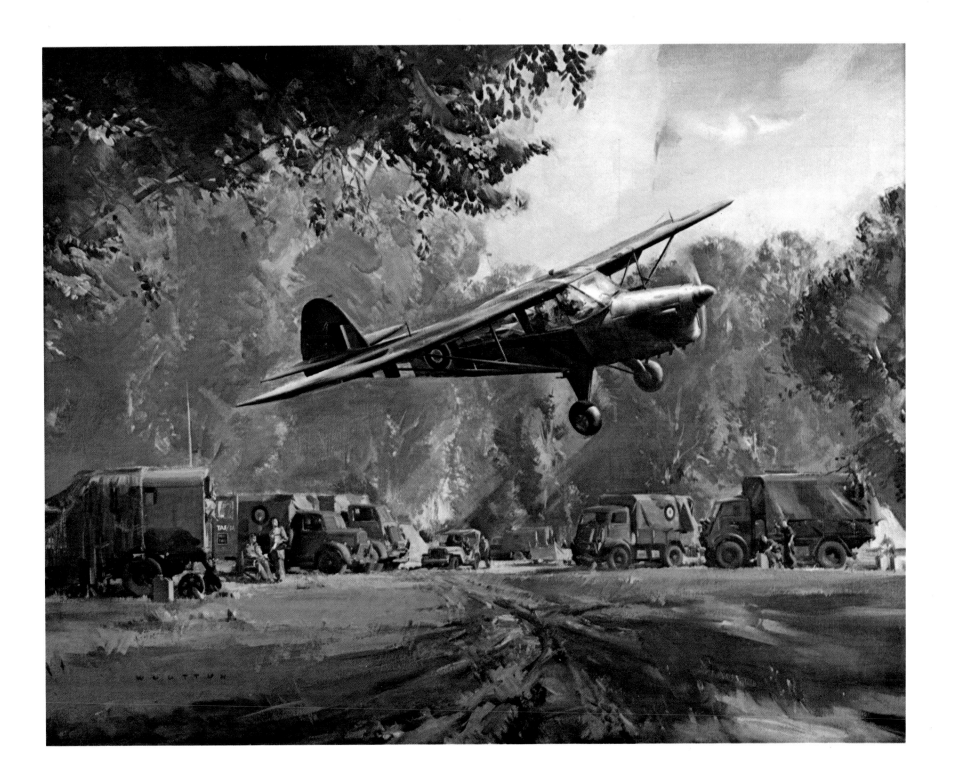

27) PR Mosquito landing on a flooded airstrip.

*"An impression of the arduous conditions prevailing during
Monsoon season at Mingaladon Airstrip, Rangoon, Burma in 1945.
Although the take-off and landings claimed many casualties these
hazards were not so great as those encountered while flying through
cumulo-nimbus cloud. From a few hundred feet above the earth they
towered upwards for more than 30,000 ft. Impossible to fly under or
over. Several aircraft disintegrated flying in these perilous conditions."*

By kina permission of the Air Historical Branch

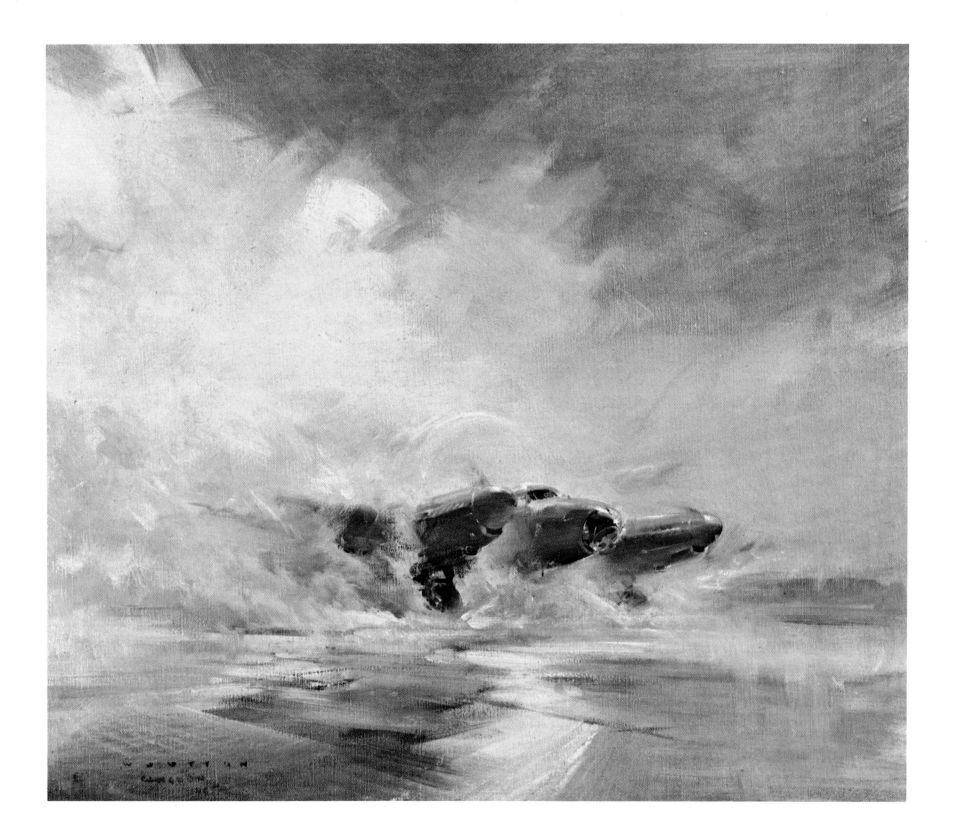

28) 35 Wing Mustangs at St. Omer, 1944.

*"When we took over this airfield it was quite evident that the
Germans had left in a great hurry. They left behind half eaten
meals and personal possessions. The device in the foreground was
one of a large number, probably intended to prevent glider landings.
We found them useful to mark bomb craters on the perimeter track
until they could be filled in and made serviceable."*

By kind permission of Strike Command. RAF

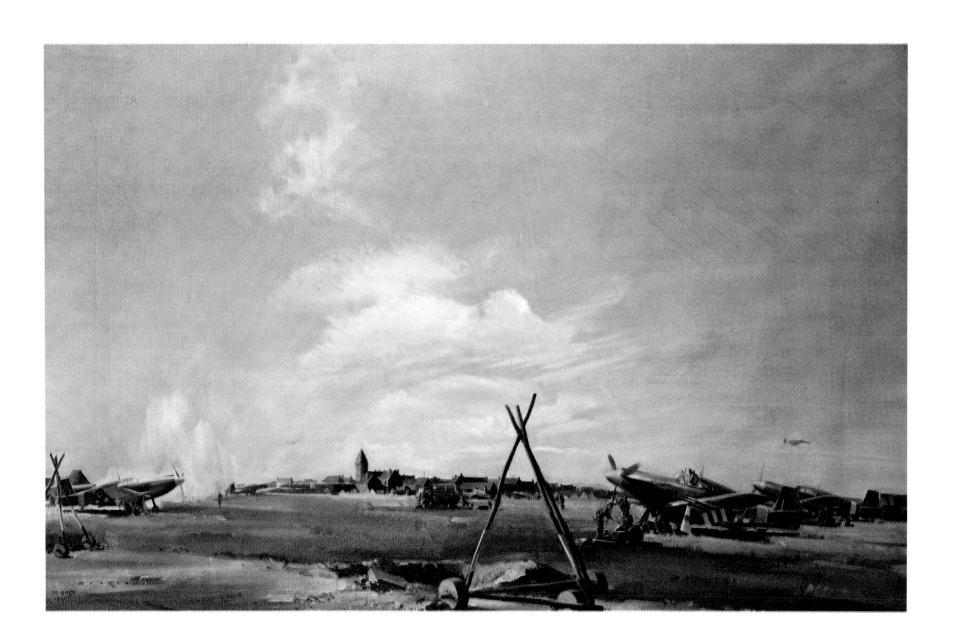

29) Mustang undergoing maintenance, Normandy, 1944.

"One of the more peaceful scenes I thought should be recorded. It was painted at Fresny Folney, just north of Dieppe. The scene illustrates the cooperative spirit of give and take that prevailed here. Aircraft were dispersed in nereby fields away from the dusty airstrip. The farmers carried on with their work in the same fields. Painted in one sitting while sustained by a litre of rough cider presented to me by the farmer working in the background. Damaged by shrapnel."

Owned by the Artist

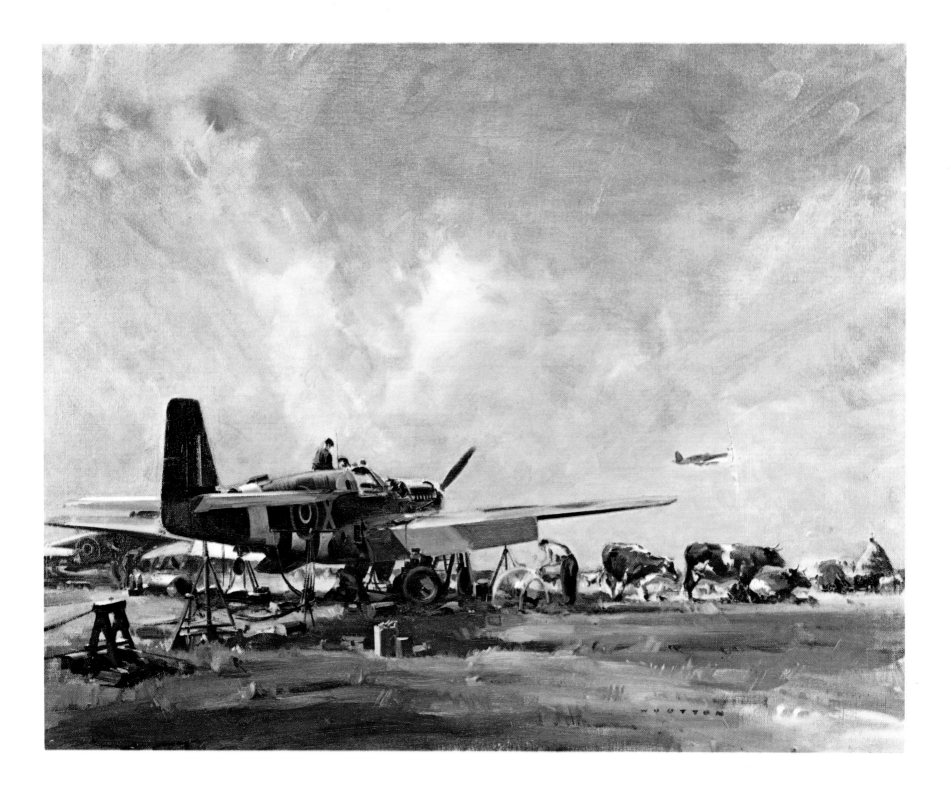

30) Hawker Typhoon, Normandy 1944

"Shortly after D-Day I attached myself to 121 Wing 83 Group. German tank concentrations and strong points were no more than a thousand yards away. The Typhoons attacking them took off, climbed to 8,000 feet over the sea and dived on to their targets and returned to the airfield in less than ten minutes. The most difficult problem on fields and strips was the thick clouds of limestone dust. When water was available the strips were sprayed after dark."

Owned by the Artist

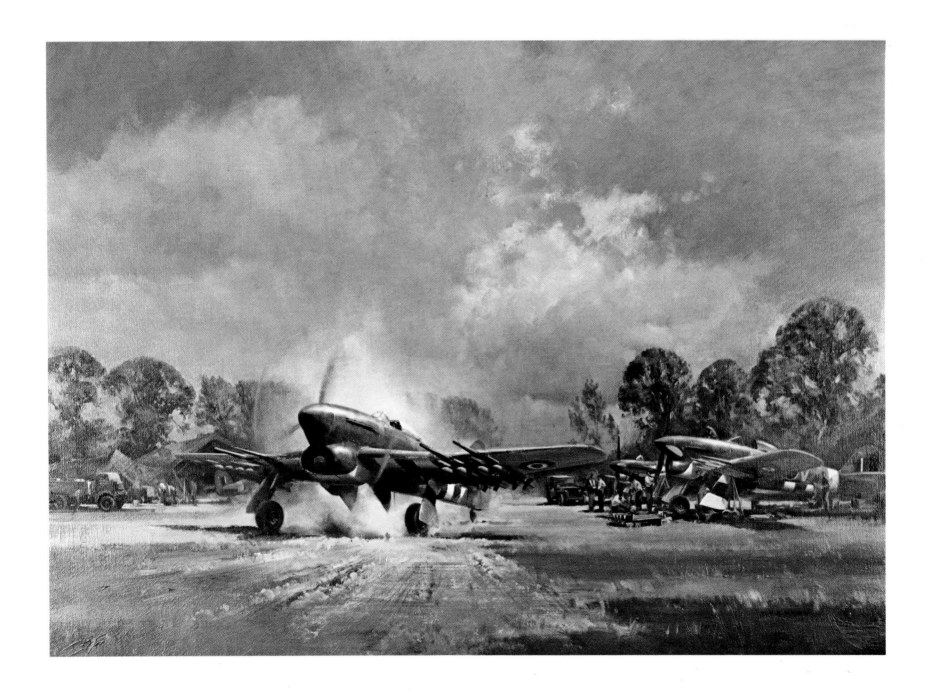

31) Typhoons at Falaise Pocket

"The intervention of the Tactical Air Forces, especially the rocket-firing Typhoons, was decisive." General von Luttwitz

"The assault lasted for 10 days and turned defeat into an utter rout. The aircraft took off in pairs, averaging over one thousand sorties a day.
"I went down to the battlefield together with the pilots, the ground was littered with burnt out vehicles and armour, some caught nose-to-tail in deeply cut roads. The gray-clad bodies of German soldiers were everywhere, some still in their vehicles sprawled over the seats, others on the running boards staring up into the sky, while in the neighbouring fields lay those who tried to seek safety off the roads.
"It had to be painted, the dust and smoke of battle would have prevented any photographer obtaining an overall picture. Although I had to omit a great deal of the unpaintable. When I showed the painting to my C-in-C he looked at it intently for awhile and said, 'not enough dead Germans.'."

By kind permission of the Imperial War Museum

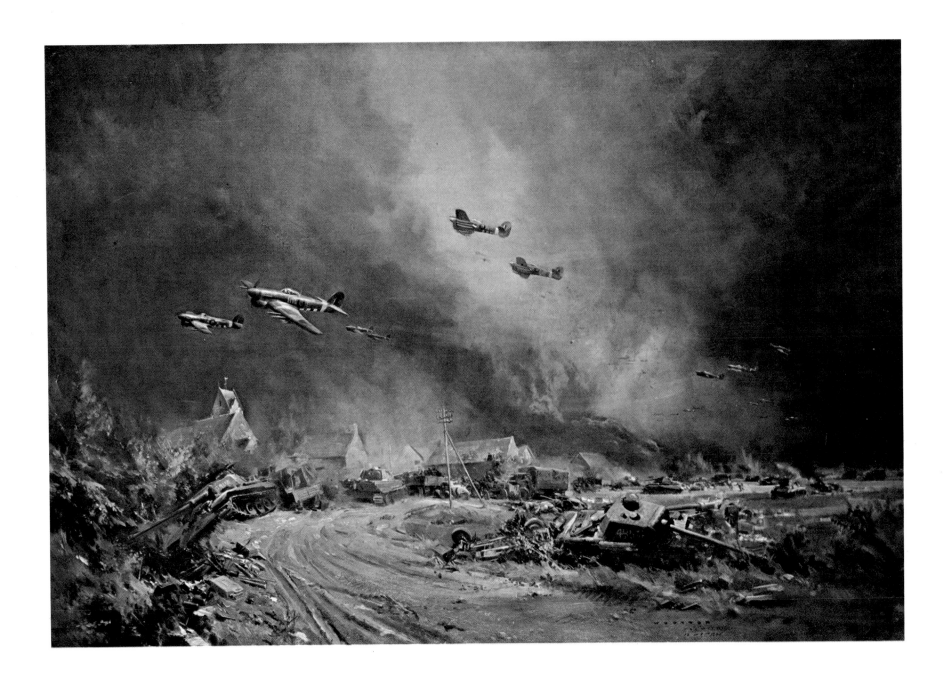

32) Arnhem Aftermath

"Snag gang at work dismantling a Stirling. By this time we were at Ghent. This Stirling failed to return to its base in England after Arnhem."

By kind permission of the Air Historical Branch

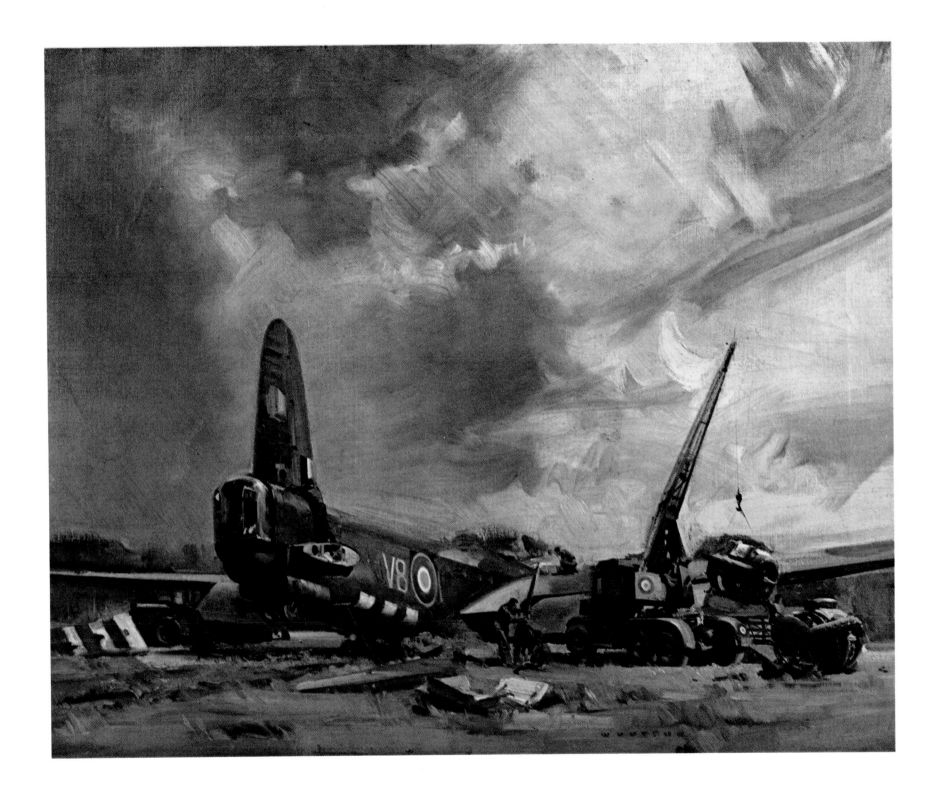

33) Last Operational Flight

"August 14, 1945 'B' Flight, Hurricanes of 28 Squadron, (Tac-R) taking off from the airstrip at Meiktila, Burma. August 15th was declared VJ Day."

By kind permission of the Chief of Air Staff and the Air Historical Branch, RAF

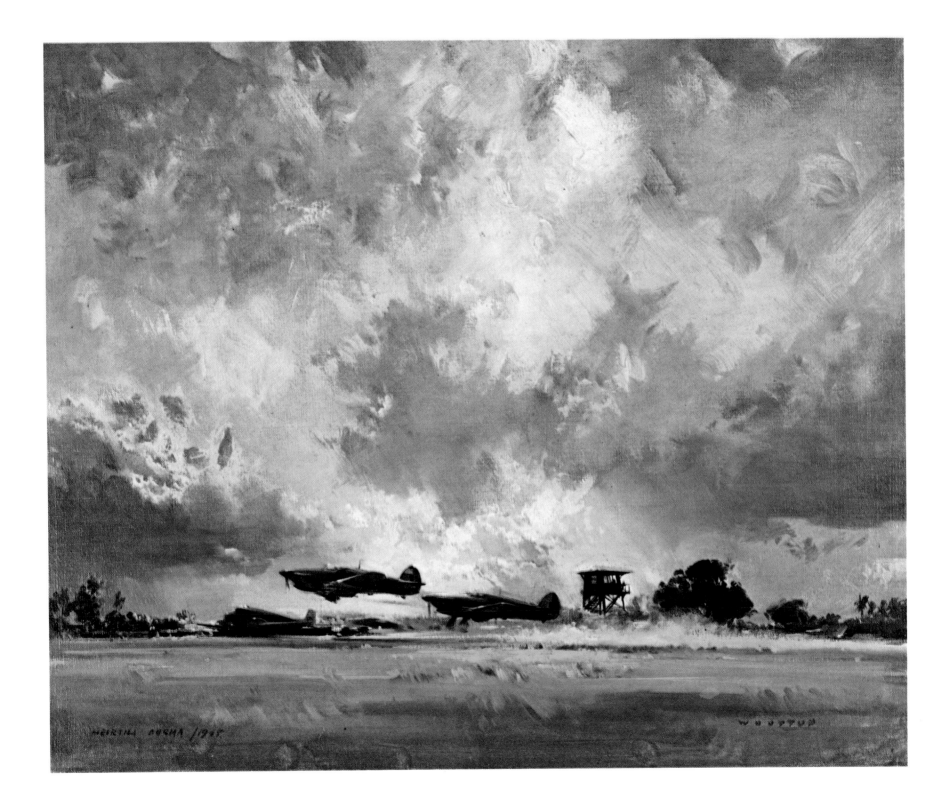

34) North American B-25 Mitchell

Squadron Leader Eric Leeke, RAAF of 7 Emergency Special Duties Squadron based at Agartala, flying over the Shwe Dagon Pagoda, Rangoon, 1945.
"I met Eric at Meiktila after VJ Day, I taught him architectural perspective, he designed houses and built them. He also had a sheep ranch and starting with 500 increased the flock to 5,000. One day wool prices suddenly increased and one result of this was a commission from Eric to paint this picture. He very kindly sent the painting back to England to be reproduced in this book."

By kind permission of Eric Leeke

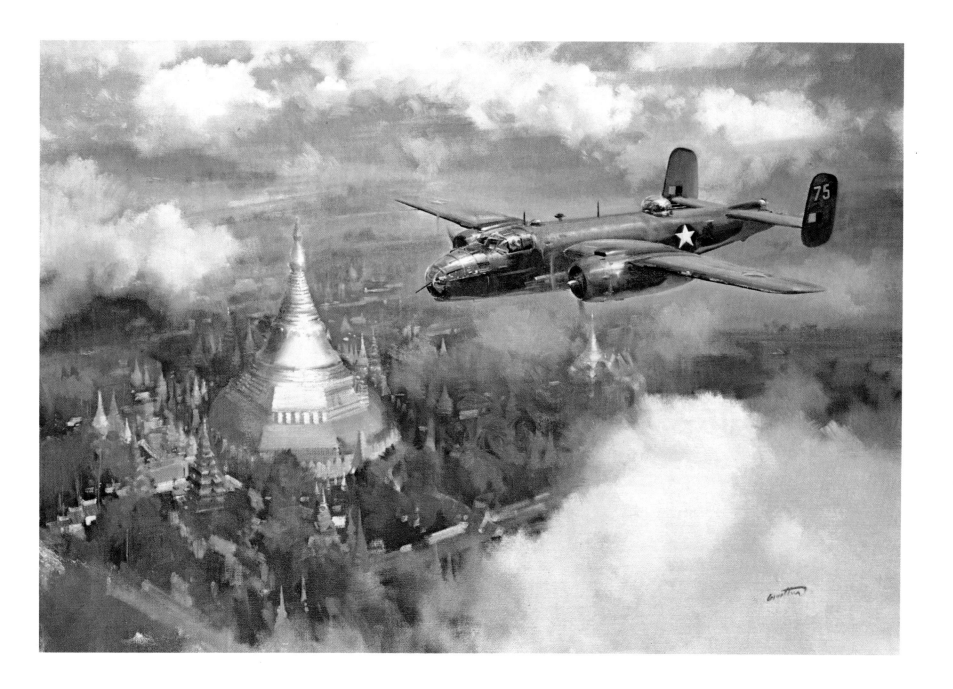

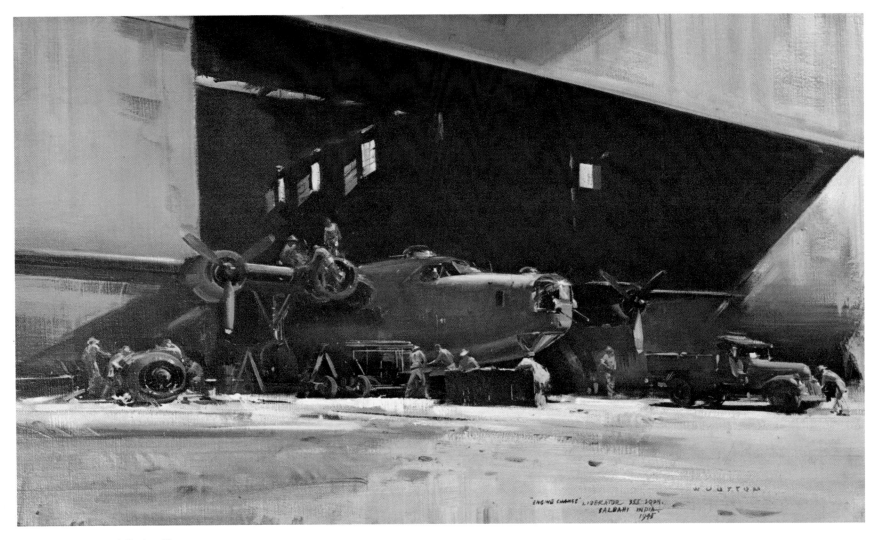

35) Engine Change

Liberator of 355 Squadron, RAF, Salbani, India, 1945.

*"Painted on the spot one day. Here the aircraft were serviced so far
as possible in the shade. Direct sunlight could raise the temperature
of the metal skin of the aircraft to a dangerous level. Lack of proper
equipment is illustrated by the position of the engine on the ground,
no cradle being available."*

*Presented to the RAF Museum, Hendon
by the Artist*

36) deHavilland Dove, Central African Airways

*"One of my first visits to Africa was sponsored by Central African
Airways. I saw a great deal of the country in and around Salisbury.
I painted Victoria Falls from the air, several landscapes and on a
later occasion the Kariba Dam."*

By kind permission of Hawker Siddeley Aviation Ltd.

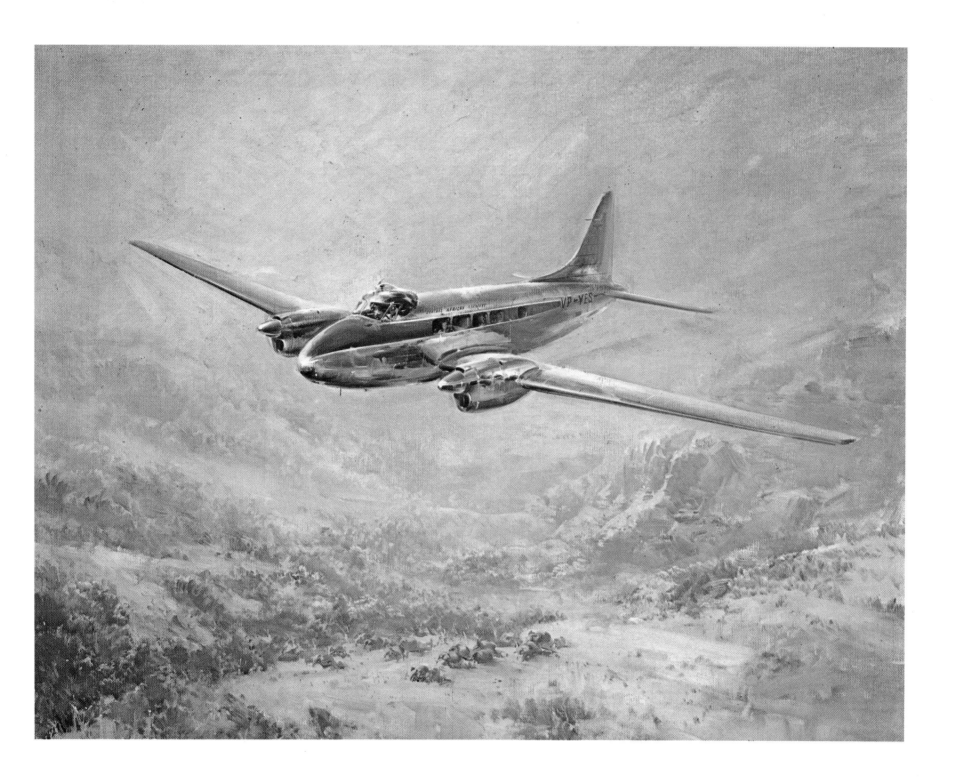

37) BOAC Constellation Over Sydney Harbour

"Shortly after the war civil airlines were reformed. BOAC invited me to paint their fleet of aircraft operating along their routes. I was given every facility to travel all over the world. This painting was made in 1948 when their policy was to show the aircraft with some degree of prominence. In fact, over the course of sixty paintings the aircraft disappeared altogether and I was engaged on purely landscape paintings."

By kind permission of British Airways

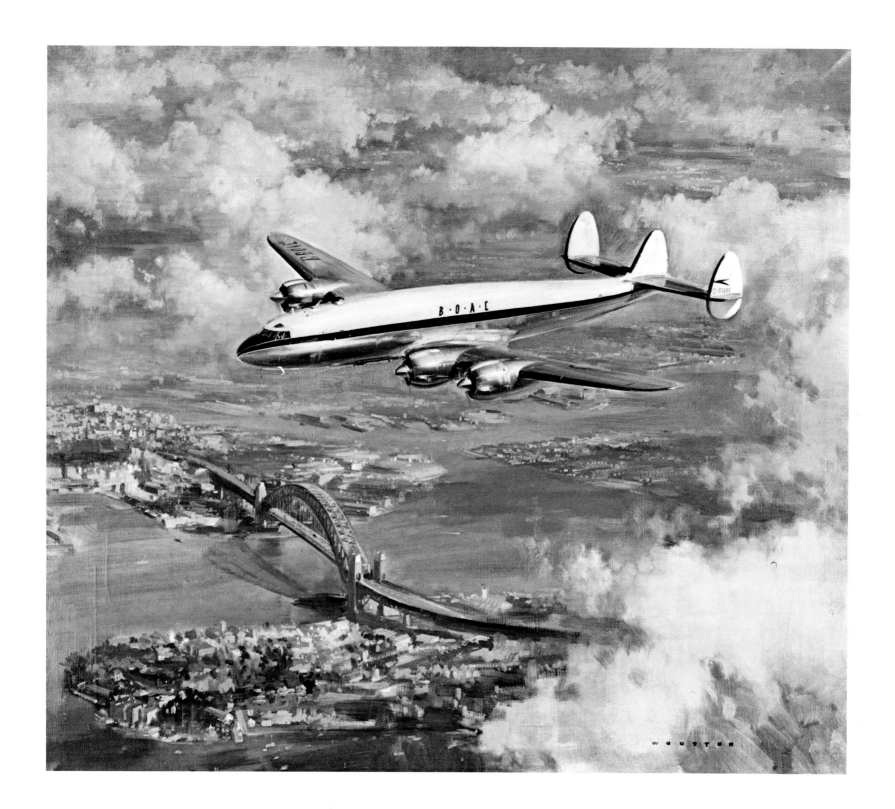

38) Comet 4C 216 Squadron, RAF taking off from
Kai Tak, Hong Kong.

*Commissioned by the deHavilland Aircraft Company and presented
to RAF, Lyneham. Painted at Kai Tak in 1960.*

By kind permission of RAF, Lyneham

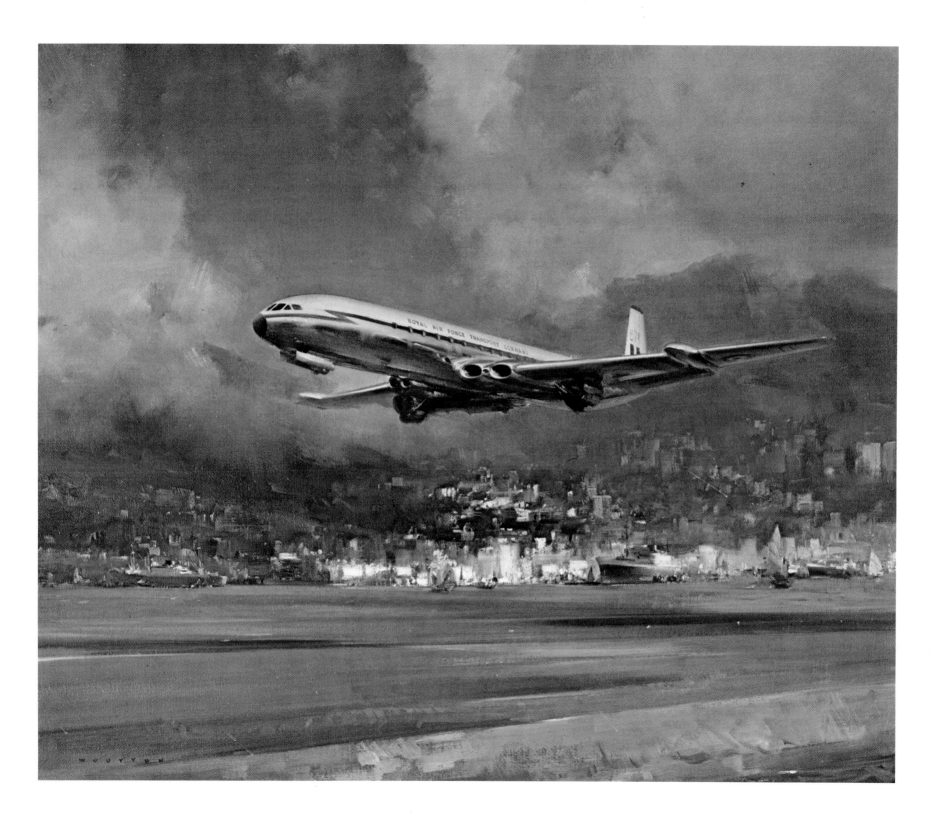

39) Javelins of 46 Squadron RAF, Odiham.

*"Painted in 1956 46 Squadron based at Odiham commanded by
Wing Commander M. E. White, DFC, AFC. This unit being the
first to be equipped with this aircraft was given the task of working
out the operational techniques before the aircraft went into full
scale service.
"When I visited Odiham to make this painting the weather was wet
and the sky practically ten/tenths cloud, not exactly ideal for
painting or flying."*

*Presented to Strike Command
by the Artist*

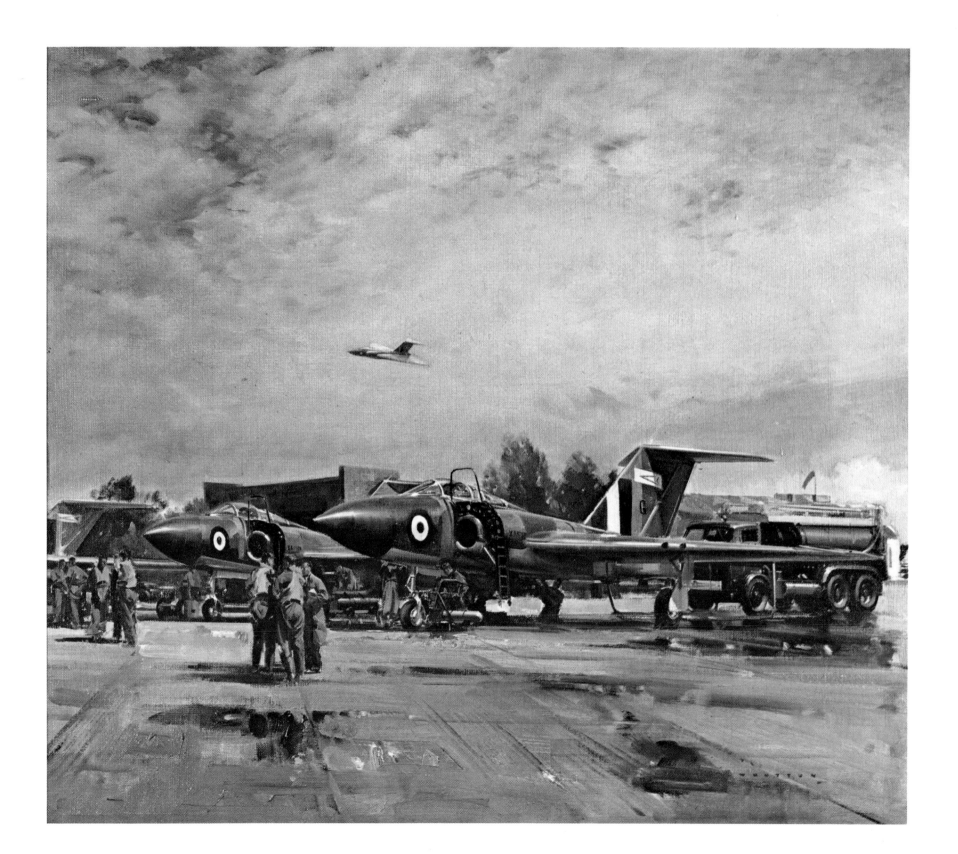

40) Lightnings of 56 Squadron, RAF, Wattisham.

"Commissioned by the Royal Air Force in 1965, I was given the choice of 56 Squadron or Treble 1. A difficult decision to make. It was while studying the squadron's records that listed so many famous names that I was moved to paint this Squadron. Several years later I received a commission from America to paint 56 Squadron S.E. 5A's of 1917 (Plate 3)."

By kind permission of Strike Command, RAF

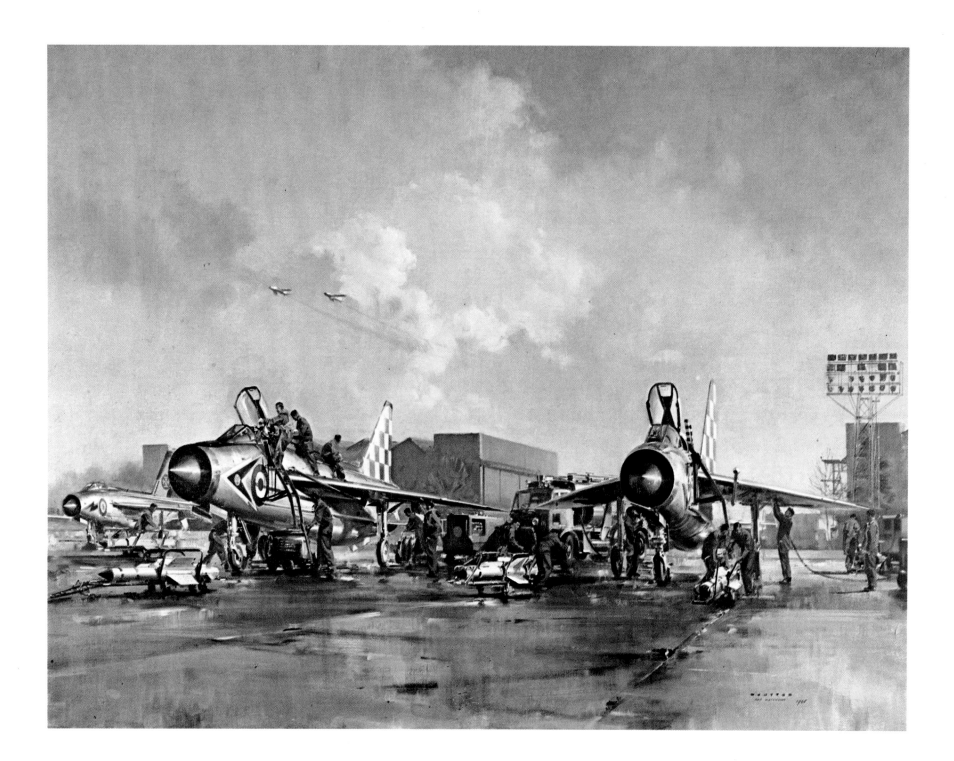

41) Spitfires In The Rain

*"The famous 609 (West Riding) Squadron, Royal Auxilary Air
Force. The first Squadron of Spitfires to score 100 victories."*

By kind permission of Jeffrey Quill, OBE, AFC

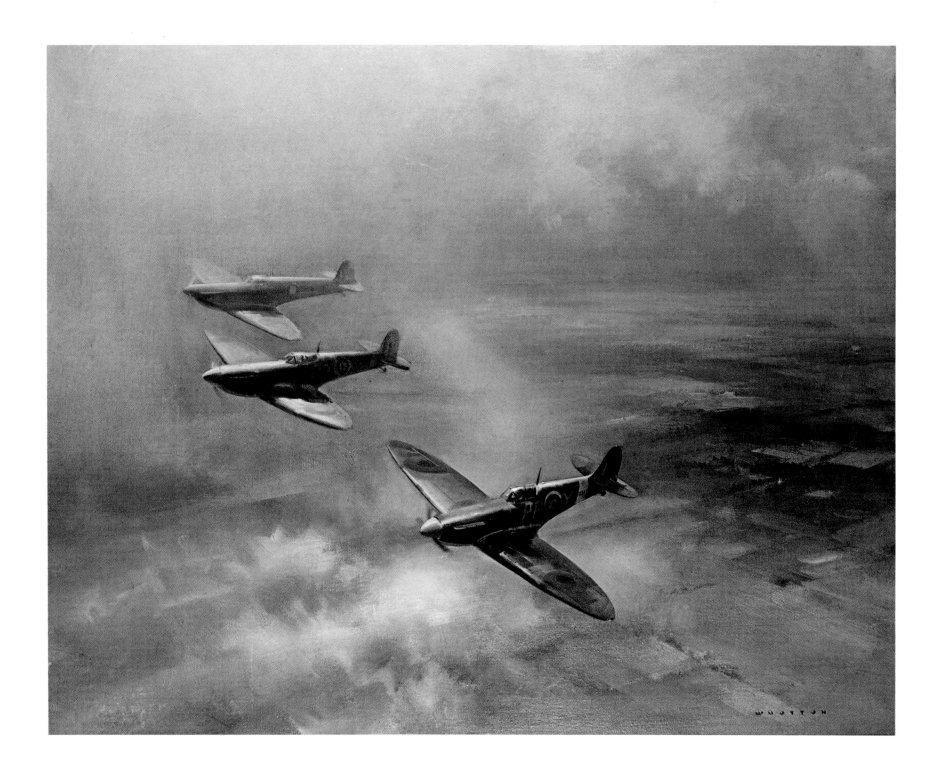

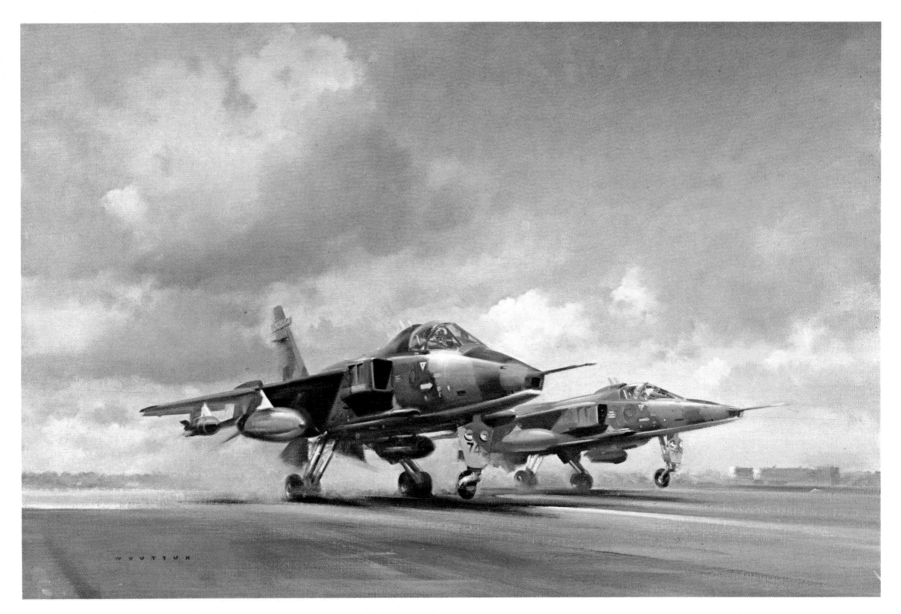

42) Sepecat Jaguar GR 1

"The Anglo-French tactical strike and reconnaissance fighter,
6 Squadron RAF, Coltishall."

Owned by the Artist

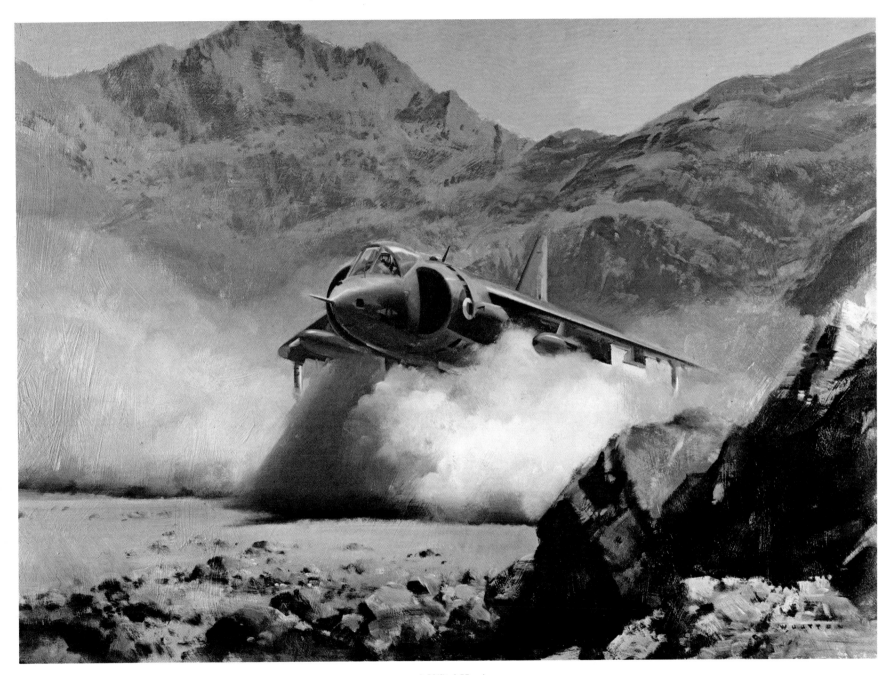

43) V/Stol Harrier

*"Capable of flying a complete range of armed missions the V/Stol
Harrier can operate from a small aircraft carrier, or a car park,
jungle clearing, or desert carrying 3630 kgs. of weapons."*

Owned by the Artist

TITLES IN THIS SERIES

KAY NIELSEN

THE ENGLISH DREAMERS

THE MARINE PAINTING OF CARL G. EVERS

THE WESTERN PAINTING OF JAMES BAMA

TEMPTATION

ARTHUR RACKHAM

THE CHRISTMAS BOOK

THE FANTASTIC ART OF FRANK FRAZETTA

EDMUND DULAC

HOWARD PYLE

THE FANTASTIC CREATURES OF EDWARD JULIUS DETMOLD

THE PAINTINGS OF CARL LARSSON

ONCE UPON A TIME

Send mail order requests to:
Peacock Press/Bantam Books,
Dept. FC
414 East Golf Road
Des Plaines, Ill. 660016